DATE DUE

GAYLORD PRINTED IN U.S.A.

6 ARTISTS PAINT A STILL LIFE

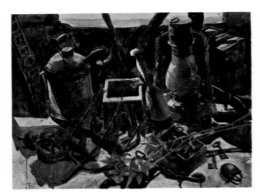

BERT DODSON

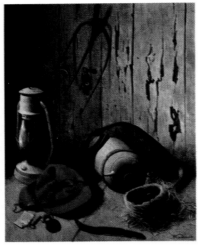

ALPHONSE RADOMSKI

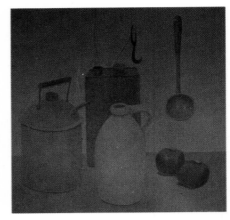

ENID MUNROE

LEONARD EVERETT FISHER

FRANKLIN JONES

WARD BRACKETT

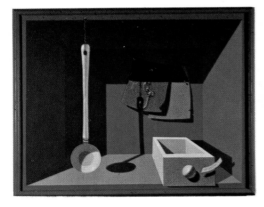

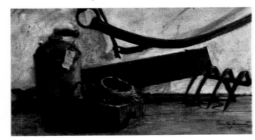

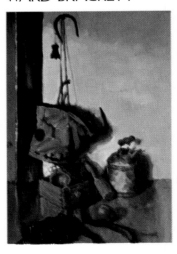

EDITED BY CHARLES M. DAUGHERTY

6 ARTISTS PAINT A STILL LIFE

ENID MUNROE
LEONARD EVERETT FISHER
ALPHONSE RADOMSKI
BERT DODSON
FRANKLIN JONES
WARD BRACKETT

 PUBLISHED BY NORTH LIGHT PUBLISHERS
WESTPORT, CONN.

Published by NORTH LIGHT PUBLISHERS, an imprint of
WRITER'S DIGEST BOOKS, 9933 Alliance Road,
Cincinnati, Ohio 45242

Manufactured in U.S.A.
First Printing 1977
First Paperback Edition 1983
Library of Congress Cataloging in Publication Data

Main entry under title:

6 artists paint a still life.

 Includes index.
 1. Still-life painting—Technique. 2. Still-life
painting, American. I. Munroe, Enid. II. Daugherty,
Charles Michael.
ND1390.S59 751.4 76-52852
 ISBN 0-89134-065-3

Designed by Walt Reed
Photography by Bill Noyes

CONTENTS

INTRODUCTION

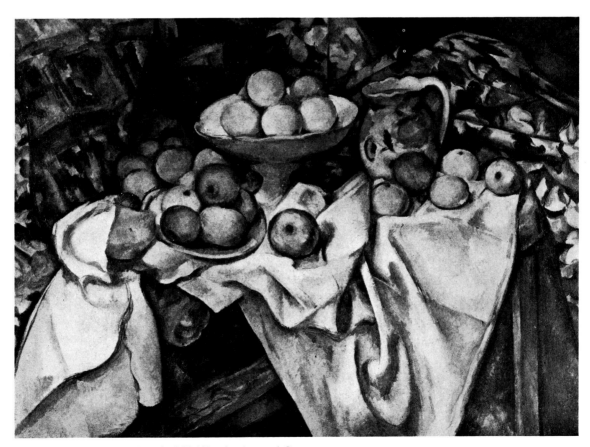

PAUL CEZANNE (1839-1906). *Still Life; Apples and Oranges.*
The Louvre Museum, Paris

6

The art of drawing and painting inanimate objects introduces all the problems that an artist must solve in making pictures, minus some of the complexities that pertain to interpreting the living figure — human or animal.

For this reason still life is often the subject of the aspiring artist's first ventures with paint and brushes.

Always available, motionless and tireless while the artist works, offering the possibility of infinite variety of shape and arrangement, the still life set up is the nearest thing to the ideal, all purpose, foolproof model.

Which is not to say that still life is for beginners only. Most representational artists are involved with it, in one form or another, throughout their careers. Many turn to it from time to time as an exercise in fundamentals. For some it offers all the reference needed to express an entire credo.

An intelligently conceived and well executed still life speaks for itself. No object is without meaning unless it is exploited until it becomes a cliche. If candlesticks and porcelain Buddhas ever had a message for the average picture viewer it has long since lost its impact. And yet some of the most commonplace things speak eloquencies. Jugs and bowls and bottles, fruits and vegetables, tools and articles of clothing — such things are civilization's souvenirs, as constant as mankind's habitation of this planet.

The highest aim of the visual artist is two-fold — to translate form, space, rhythm and color into a coherent, harmonious statement with paint applied to a flat surface, and at the same time to imbue that statement with a message by means of subject matter that represents, suggests or symbolizes an idea. Because artists sometimes resort to still life as a convenient way to separate these twin objectives and pursue one without being burdened by the other it is sometimes mistaken for a minor form of painting.

The fact is, however, that by freeing the artist from literary and illustrative obligations still life enables him to concentrate on pure painting values, which is why there are many still lifes among the masterpieces of western art.

Still life flowered as a distinct branch of European painting in the late 16th and the

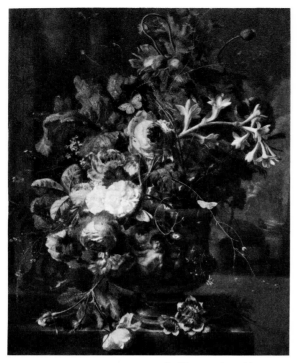

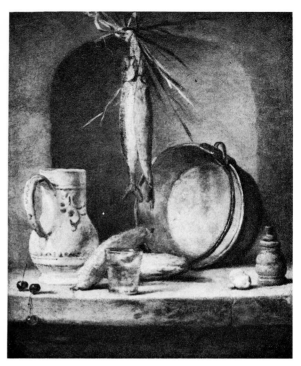

JAN VAN HUYSUM (1682-1749). *Flowers in a Vase*
The Louvre Museum, Paris

JEAN-BAPTISTE CHARDIN (1699-1779). *Still Life*
Collection D. David Weill

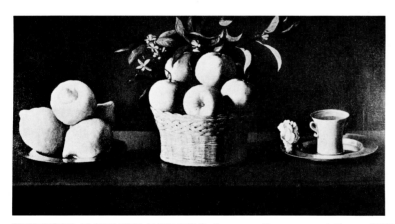

FRANCISCO ZURBARAN (1598-1664). *Lemons, Oranges and Rose, 1633.*
Private collection, Florence

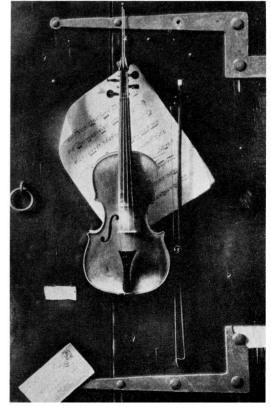

8

WILLIAM M. HARNETT (1848-92). *The Old Violin*
Collection W. J. Williams

17th centuries with large, meticulously finished canvases of Dutch and Flemish masters who excelled at painting tables elaborately spread with fruit, vegetables, fish and game.

The influence of these artists reached all over Europe. The greatest masters of Spain, including Valasquez, Zurbaran and eventually Goya turned their hands to still life with brilliant results. In France Chardin, early in his career, painted large canvases in the manner of the Dutch still lifes. In time he simplified and refined his organization of form and space so that his later still lifes are diminutive in size but monumental in character and quality.

In the painting of the 19th and 20th centuries still life has been a prominent motif. The expressiveness of Van Gogh's art is as highly charged in his treatment of a pair of old boots as it is in his vision of a star filled firmament. Cezanne's still lifes rank among his finest canvases. For Picasso and Braque a few commonplace objects were the models used in shaping cubism. Throughout his career Giorgio Morandi devoted himself almost exclusively to painting variations of a few still life themes.

Imagine how enlightening and inspiring it would be to witness the processes through which these artists developed their paintings. Unfortunately that's not possible, but the essential concepts and practices applicable to successful still life painting are shared by all artists of talent and experience, as is demonstrated in the following pages where six contemporary painters show by means of photographs and texts, each his own approach to and solution of the problems pertaining to still life painting.

CHARLES M. DAUGHERTY

GIORGIO MORANDI (1890-1964). *Still Life, 1942*
Private Collection

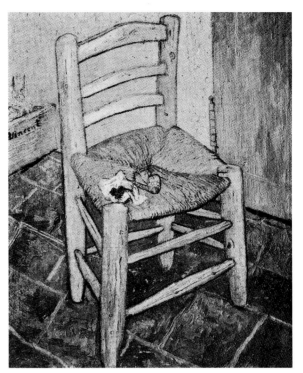

VINCENT VAN GOGH (1853-1890): *The Yellow Chair*
National Gallery, London

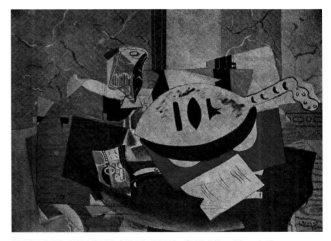

GEORGES BRAQUE (1882-1963). *Still Life, Mandolin*
Private Collection

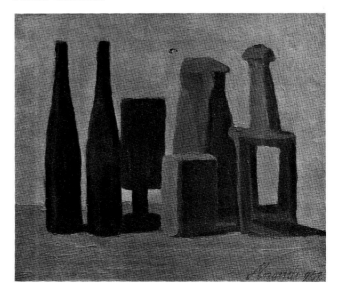

1 LEONARD EVERETT FISHER

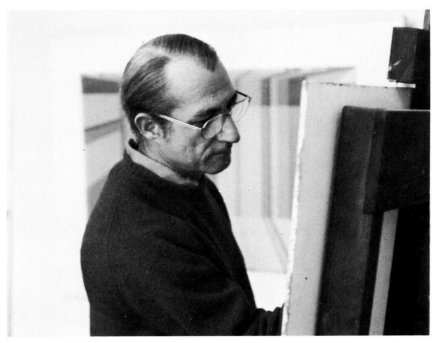

The artist at his easel.

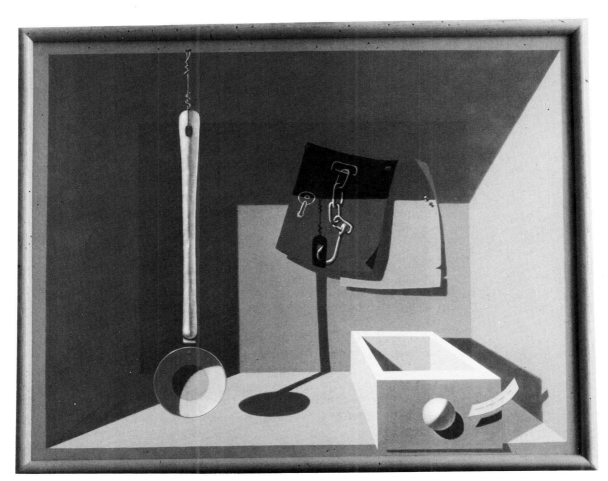

His completed still life painting.

Leonard Everett Fisher is a masterful draughtsman and a meticulous craftsman. These qualities shape his paintings and illustrations and provide the essential content of his message as a teacher.

His bright, sharp, often astonishingly illusionistic paintings have been widely exhibited and are in a number of major collections, including the Library of Congress, The Butler Art Institute, the New Britain (Conn.) Museum, and half a dozen colleges and universities.

Still life is conspicuous in this artist's choice of subject matter for his paintings. His concept of still life, however, focuses not so much on arrangements of related, familiar objects as on objects isolated in space. It is the space, in fact, the emptiness around things, the distances between them, the vacuum in which they exist that is often the true subject of a Fisher still life.

He is also one of the best known and most prolific illustrators of juvenile books in America today, with some two hundred titles to his credit. Thirty of these are books he wrote as well as illustrated.

As a teacher Fisher is neither the artist who sometimes teaches nor the teacher who sometimes paints, but rather a thorough-going and committed professional in both roles.

Following his graduation from Yale University School of Fine Arts with both the Bachelor and Master of Fine Arts degrees he served on the faculty of that institution and, subsequently, as dean of the Whitney School of Art in New Haven. Currently he teaches at the Paier School of Art in Hamden, Connecticut.

He is a member of Audubon Artists, The American Institute of Graphic Arts, The Authors Guild and League of America, The Silvermine Guild of Artists, and the New Haven Paint and Clay Club.

"The term still-life brings to mind a certain traditional kind of painting in which the artist, working from nature, paints his impression of an arrangement of objects. We think of Chardin, of the old Dutch masters with their dead rabbits and bowls of fruit, of the Impressionists and of Cezanne.

"But I don't approach still-life exactly this way. What I'm really interested in painting is not the objects themselves but forms in space — the space occupied by volumes, the space around them, between them, in front and behind.

"How do you create the illusion of space within the borders of a picture? Well, there are a number of ways. In order to confine space you have to define its limitations. In planning my picture I'm going to think of the whole format as space enclosed by the sides, top and bottom of a box. The box is open in front and the viewer is looking into it.

"Perhaps the box is my symbol for a finite universe. By defining it with positive boundaries I make it a compact universe that I can handle — in which, in fact, I, the artist, am the omniscient creator. As such I follow the example of the Great Creator and do my job in six days and rest on the seventh.

"On the first I buy the materials, plan my picture, and gesso the panel. On the second day I make the drawing and begin painting. On the third, fourth, and fifth, I paint. On the sixth, I paint some more and finish. And on the seventh day I rest.

"I'm being facetious, of course, but roughly that is the outline of the procedure in executing almost any painting. Moreover, I do create my micro universe within the box entirely from my own inner vision.

"I do not draw from nature — from the objects arranged as they'll appear in the picture. I'll study them initially, and I'll look at them from time to time to keep their essential characteristics in mind, but that's about all. The arrangement and the lighting will be worked out in my head. At the most I might do several little thumbnail sketches that roughly map out what I have in mind.

At the outset I'm not sure whether my composition will occupy a vertical or horizontal format. I don't work from an actual set up of the objects but make the arrangement conceptually, as these thumbnail sketches illustrate.

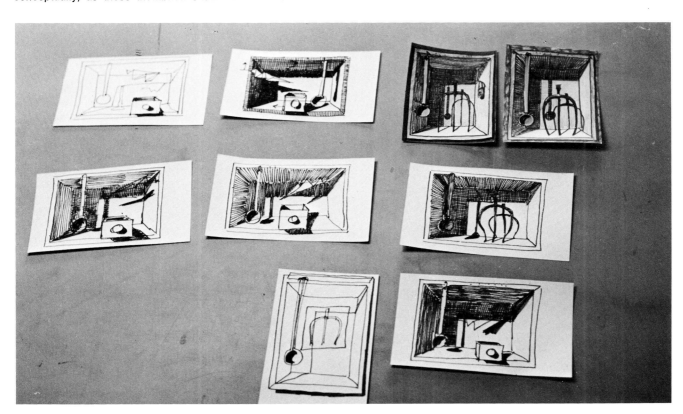

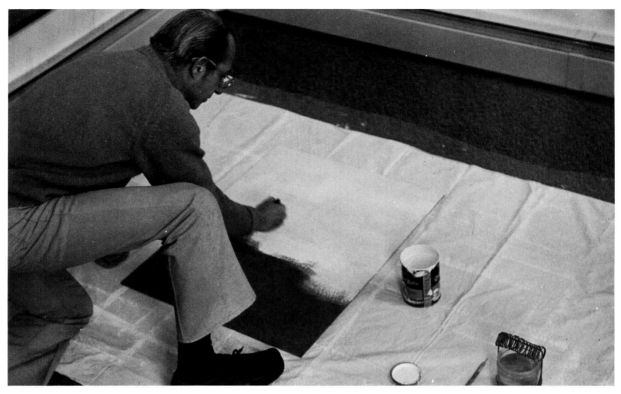

The Masonite panel is placed on a flat surface for gessoing.

"While all this thinking and planning is taking place I prepare the panel on which the picture will be painted. I don't use canvas. My favorite painting base in one-quarter inch thick prestwood (Masonite). It must be untempered. The tempered variety has oil in it. If you paint with acrylic, as I do, there's a danger that the paint won't adhere properly and permanently to the slightly oily surface.

"Before I can begin painting, the raw surface of the panel must be covered with a ground. For this I use a commercial, ready-mixed gesso that is a chemically sound base for either oil or acrylic. Putting on gesso involves the application of liquid to a dry, absorbent material and unless it's done properly the panel is apt to warp. The secret is to place the panel flat on the floor or on a table in a dry room with a moderate temperature so that it doesn't dry either too fast or too slowly. As a further precaution against

warping, I first apply a single coat of gesso to the back (the rough) side of the panel. After it has thoroughly dried I flip it over and gesso the smooth (painting) side. I apply as many as seven coats, brushing each at right angles to the last so that the brush marks build up a criss cross texture that's like the weave of a fairly smooth canvas. It's important to let one coat dry before putting on the next and to keep the panel lying flat throughout the whole operation. If you do it right you won't have to worry about the panel warping.

"When the gessoed panel is completely dry I put a slight bevel all around the edges, using an electric sander. This keeps the edges from chipping. I don't sandpaper the surface of the gesso because I like that slight woven texture made by the cross brush strokes. However, a smooth as marble surface can be achieved by sandpapering, should it be desired.

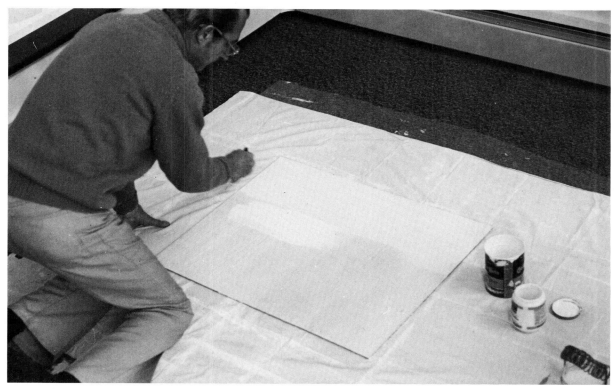

The painting surface gets six or seven coats. The back is given one coat to prevent the panel from warping.

Beveling the edges prevents chipping.

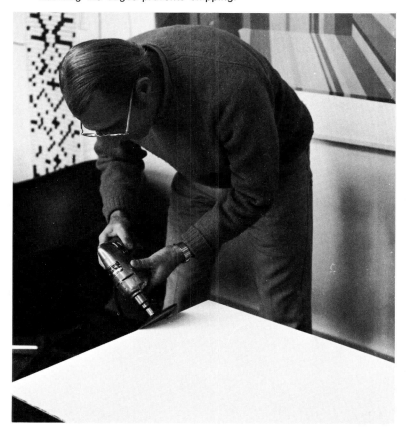

15

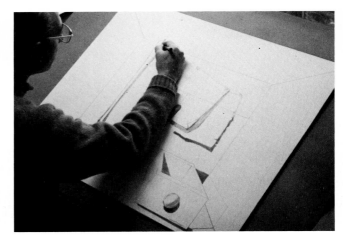

I next translate my chosen sketch into a careful, precise drawing.

"Now I'm ready to begin drawing on the panel. I have a clear idea of what objects are going to be in the painting but remember, I don't make a set-up and light it and then copy what's in front of my eyes. The drawing will come out of my head — a product of calculation more than of observation.

"For example, what will be the scale of the objects in respect to the box that contains them? Will they be large or small? How will they be arranged? Where do I want the shadows to fall? These are graphic considerations that I treat with mathematical exactness.

"First, the box that frames and contains the entire composition. The edges of the illusionistic box that I'm about to draw coincide with the edges of the panel. The frame into which the panel will fit when the painting is finished will overlap the edge by a quarter of an inch all around. As I want the edge of the box to be three quarters of an inch wide I measure one inch all around, knowing that one quarter of this will be covered by the frame.

"I measure everything out carefully because the illusion of space that I'm creating must be a very measurable, precise and sharply focused space.

"In determining the perspective I have in mind that the painting, when finished, will hang on a wall at eye level with whoever looks at it. So that the perspective in the painting will be consistent with a viewer's sense of reality I establish a single vanishing point at dead center of the panel. This means that all the vertical lines of the box and everything in it will be at right angles to the horizon. All the horizontal lines that appear to be receding from the picture plane will converge at the single vanishing point.

"The illusion of deep space begins to take form with the drawing. As I plot the placement and contours of the objects in the box I know that I'll be using everything within the artist's means — lighting, shadows, values, color — to reinforce the sense of depth so that each object appears to exist on a different plane, from up front near the viewer to all the way back against the rear wall.

"The correct use of light and shade, of dark and light values, is an important element in making the illusion of space. I use a scale of tonal values that goes from zero (white) to 10 (black). In between are 9 graduations of gray, with value 5 as an absolute halftone.

"Values and their distribution are determined by the source of light. In this respect my concept is based on an imaginary bright light placed in front of the picture and high on the left. Such a light would cause the very definite cast shadows that I want, along with strong contrasts between dark and light.

"Cast shadows are positive shapes, just as much as the objects that cause them. They serve to hold the eye and direct it where I want it to go. But they are shapes that we know to be without solid substance. They're illusions caused by the absence of light. As such they help to describe space in yet another way, by testifying to the emptiness between solid objects.

"I usually use a 2B charcoal pencil, sharpened to a fine point, for my linear drawing. Then with a 4B I tone in all the areas that are darker than halftone, much the way one would do an underpainting. This blocks out the glaring gesso ground so that the white won't reflect through the transparent colors in the dark areas.

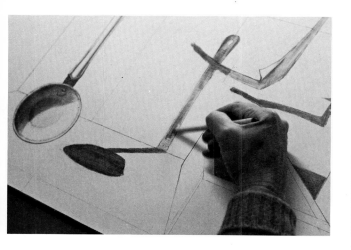
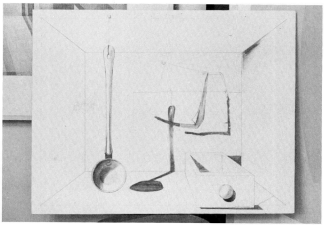

The drawing is done with a charcoal pencil. Every area that will be halftone or darker in the painting is rendered in full value with the pencil.

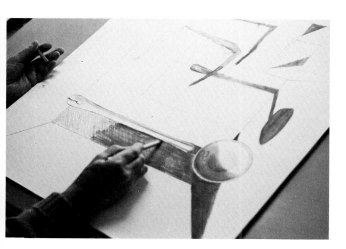
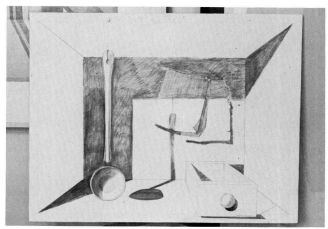

As I don't draw from direct observation, the lighting and the arrangement are conceived in my mind's eye.

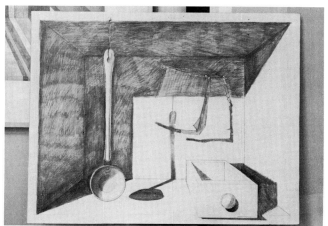

The full range of values is represented by numbers 1 to 10 and their distribution plotted in a diagram which will also serve as a guide when I mix my colors.

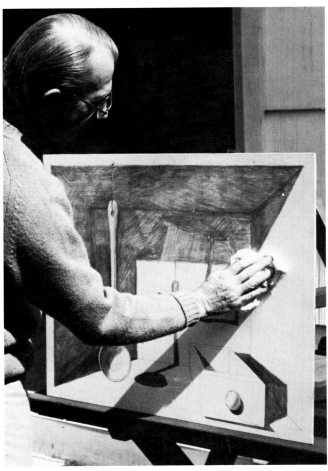

A light dusting with a soft cloth removes loose charcoal from the finished drawing.

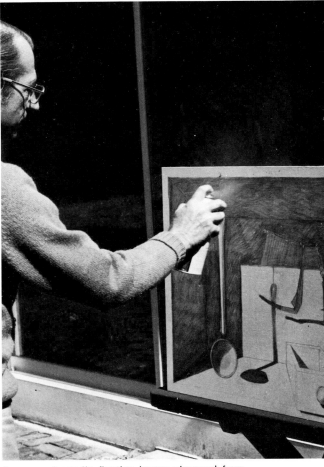

A spray of acrylic fixative keeps charcoal from smearing and mixing with the paint. When possible this is best done out of doors to avoid noxious fumes.

"When the drawing is finished I blow off the loose charcoal dust and spray with a light coat of acrylic fixative to keep the charcoal from smearing and mixing with the paint.

"By the time I'm ready to begin painting everything in the picture has been determined except color, and even this is pretty thoroughly resolved in my thinking.

"The key color decision involves the box itself. In making a color plan my chief consideration is controlling the illusion of deep space, just as it has been in every other decision up to this point.

"The interior of the box must recede. Cool colors usually recede. Therefore the box will be a cool color. I want it also to be an intense color and one that is pleasing to the eye. Then there is the important matter of relating it by means of harmonies and contrasts to the other colors I'll be using. Logic and instinct dictate the choice of blue.

"In contrast to the receding blue of the box the hanging ladle must now be a warm color that comes definitely forward. The actual ladle on which the drawing is based is a speckled, dingy, blue-gray, but in my painting it becomes yellow, as though it were made of brass, and so sets up a strong light/dark, warm/cool tension in contrast with the interior of the box.

18

The color scheme has been completely resolved in my thinking before I begin to paint.

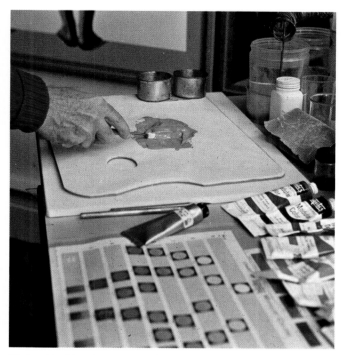

Mixing the blue to correct color and value.

"The two pieces of paper that are tacked in the box must go back of the ladle so they will be again cool and somewhat muted in value. For them I choose an olive green and a violet — colors that do what I want them to do spatially (recede) and at the same time harmonize with the blue around them because they are close in the color spectrum.

"At all stages the existence of the painting in its entirety is clear in my mind — as clear as it will eventually be on the completed panel. Therefore the process of painting is no more nor less than a mechanical act of carrying what I have visualized to a logical conclusion.

"It would be very difficult to match any of these carefully controlled colors and values if I were to run out of a mixture before an area was completely covered, or should I have to go back and retouch or change something. So I always make sure to mix more than enough and I preserve what's left over in tubes that I label and hold in reserve.

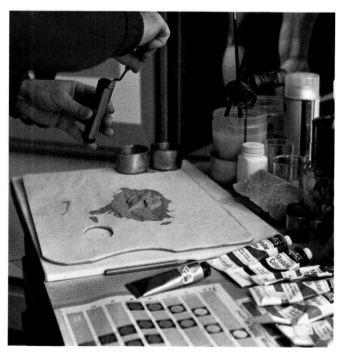

Color not immediately used is put in empty tubes and labeled.

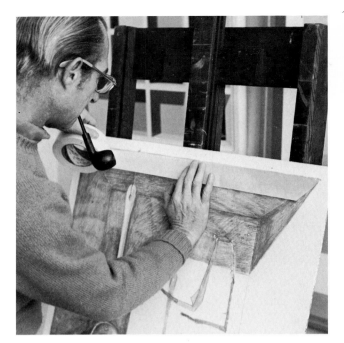
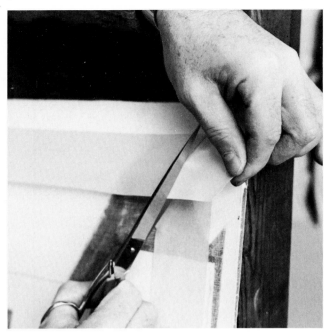

Each color area receives several coats. Tape can be removed when last coat of a given area is dry.

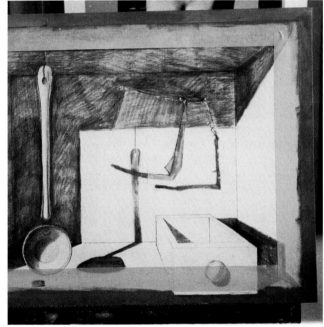

In taping over an already painted area be sure paint is thoroughly dry. Otherwise it might lift off when tape is removed.

"The final act of puttting on the paint begins, as did the drawing, with the edges of the box. I use masking tape to separate the straight edges between color areas because it facilitates the painting process and because the sharp, clean edges that result are consistent with the sharp focus, illusionistic effect I'm aiming to produce.

20

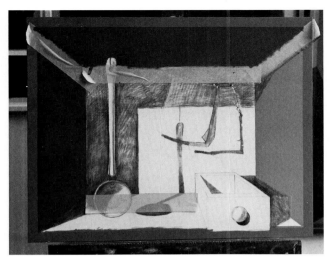
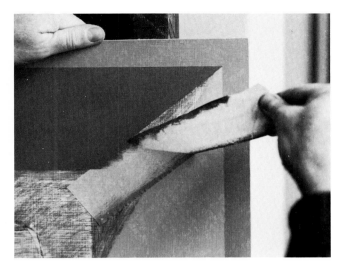

When painting up to an untaped edge the dividing line is overpainted and then redrawn (with white pencil where necessary). After painted area has dried tape can be applied along redrawn line before painting adjacent area.

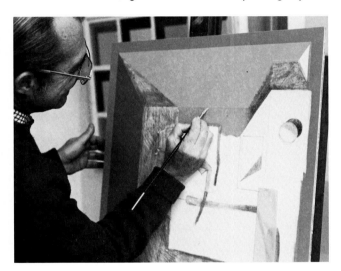
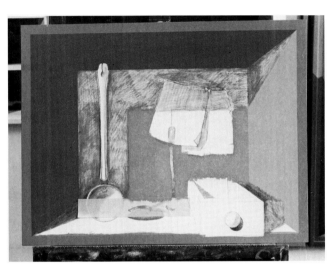

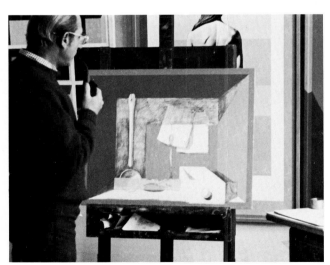
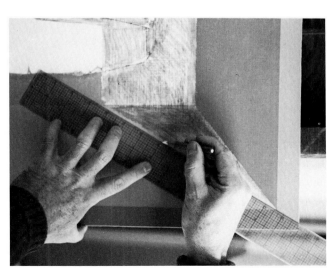

After a mixed color has been used up it's almost impossible to remix exactly the same hue and value. Therefore I make a practice of mixing not only enough of every color to cover the area for which it's intended but a sufficient amount for future use should I need it to repaint or retouch. The surplus is loaded into blank paint tubes which are labeled with the name of the painting and identification of the color.

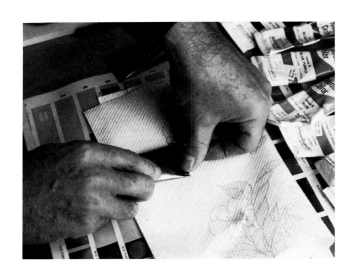

Acrylic paint dries rapidly when exposed to air. However it's possible to keep paint in a workable state on the palette for twenty-four hours or longer if it is isolated from the atmosphere by an upside down cup or glass.

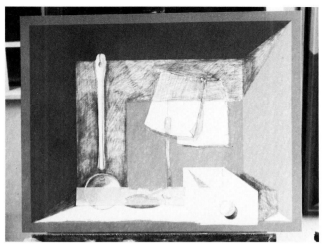

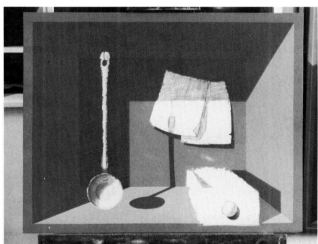

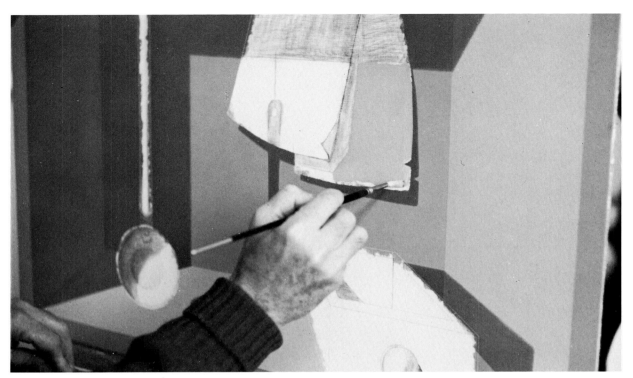

An illusion of spatial depth has been established by three objects representing foreground (the box, or drawer, thrusting out toward the viewer), middle distance (the hanging ladle), and far distance (the pieces of paper tacked to the back of the box). Cast shadows lead the eye into the picture and measure the space between the solid volumes.

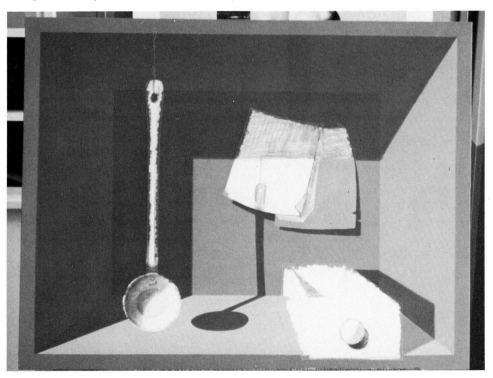

"The value relationship between the box's edges and its interior planes contributes to the illusion of light. As we have seen, the cast shadows and their strong dark/light contrast indicate a light source *outside* the box. But at the same time I want to suggest a soft, mysterious light emanating from within the box. In reality such a phenomenon might not be possible but I can make it seem so by my control of values.

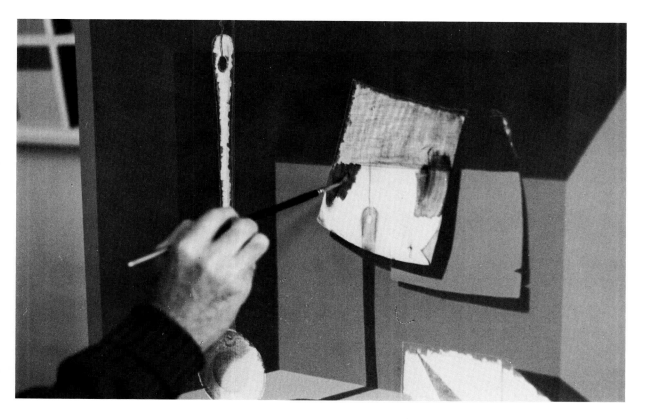

"I like the optical illusion that takes place between any two areas of flat color of different values that have a common boundary. Neither seems to be absolutely flat because where they join their respective values create the illusion of reinforcing each other — by which I mean the dark seems darker where it lies against the light and the light seems lighter against the dark. The result is the appearance of a gradation in value from the outer edges to the common edge that is so smooth and subtle that it would be all but impossible to render it with the brush.

Because my colors and values have been predetermined, I avoid trial and error and can paint each object directly.

25

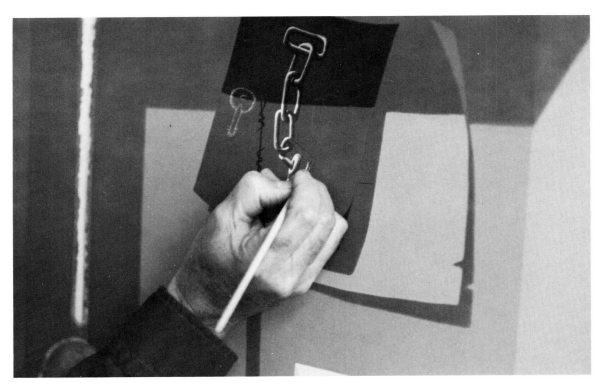

Farthest from the eye of the viewer is the back of the box, to which the two pieces of paper are tacked. As these papers bear images of other objects they imply an even deeper dimension of space. And just as the illusion of space can be extended beyond the back of the picture it can be projected in the opposite direction, so that the image of the drawer appears in front of the picture plane.

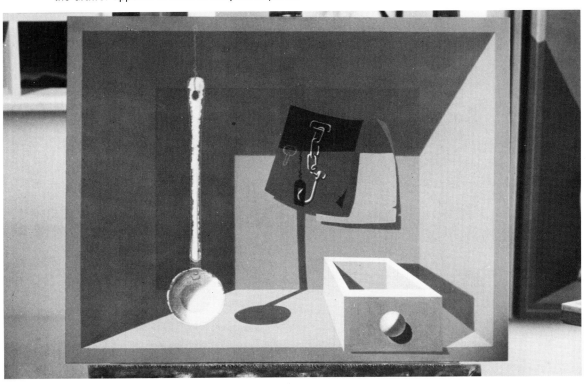

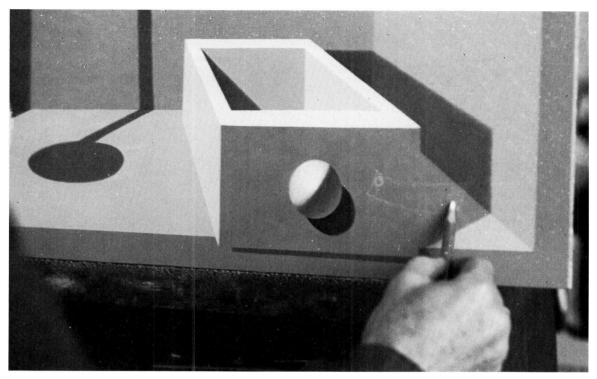

As an accent to the illusion of spatial depth I sometimes like to add something that appears to be even nearer the viewer than the foreground object. In this instance I cut a chip of paper and try it on the painting for placement. Then I paint it and its cast shadow — a detached bit of matter floating in an outer space that I have decreed in counterpoint to my universe within the confines of a box.

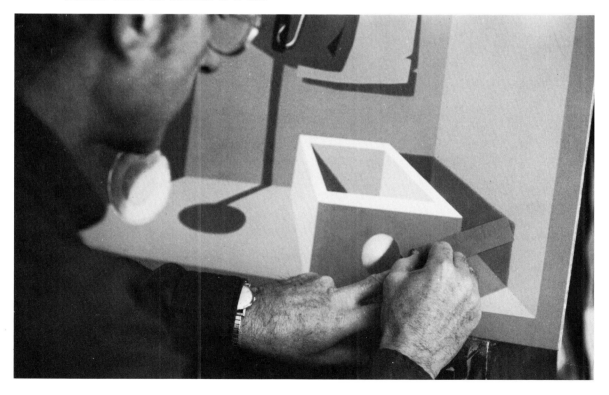

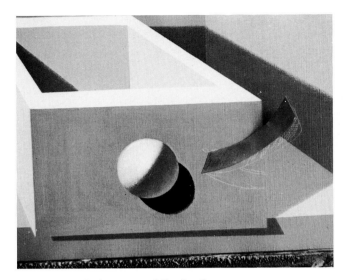

A cut-out of colored paper allows me to test the shape and placement of the floating paper strip.

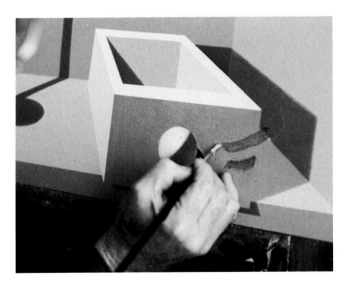

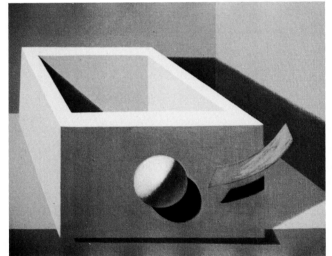

A pencilled white outline serves as a guide for blocking in the object and its cast shadow.

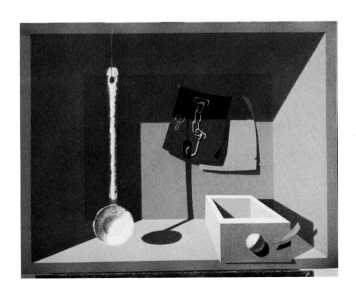

"For me painting is an illusion realized with sufficient conviction and executed with sufficient clarity to create an image that *seems* to be a realistic imitation of nature, although in nature it never existed. When I'm satisfied that I've met this challenge the job is done."

The frame is incorporated as part of the finished painting to give it an added dimension.

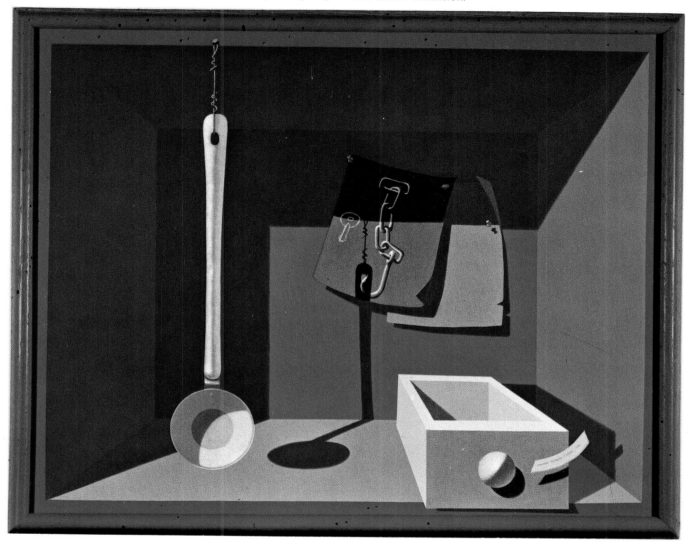

The Blue Box

29

2 FRANKLIN JONES

The artist in his studio.

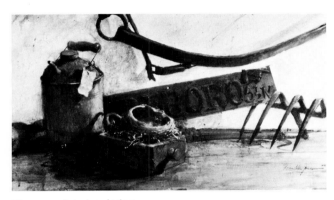

The completed painting.

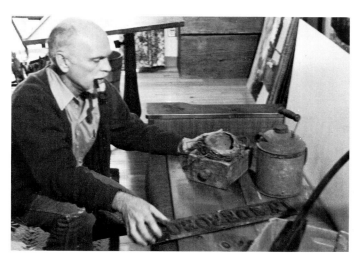

As a life-long New Englander, these objects are exactly the kind I enjoy painting most, and I spent a long time arranging and rearranging them.

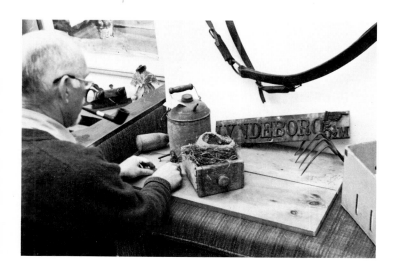

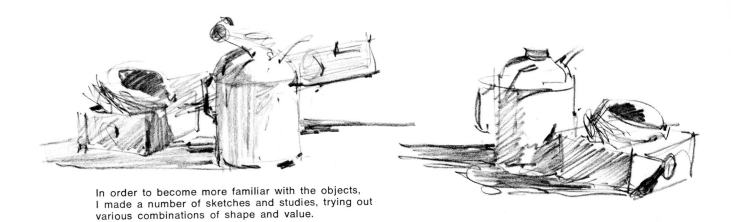

In order to become more familiar with the objects,
I made a number of sketches and studies, trying out
various combinations of shape and value.

Winner of the American Watercolor
Society's gold medal of honor in 1975
Franklin Jones is an artist who works with
unflagging affection for both his subject
matter and his craft. Whether he is painting
a still life or a landscape his precisely
executed pictures nearly always are char-
acterized by the look and mood of his native
New England.

Almost entirely self-taught, Jones began
his career on a part-time basis, painting
signs and drawing editorial cartoons. During
World War II, while serving in the United
States Marine Corps, he was assigned as an
artist to make posters, paint murals, illus-
trate books and pamphlets and paint easel
pictures.

After the war, striking out as a full-time
professional, he drew a weekly cartoon for
The New Hampshire Sunday News, did text
book illustrations, painted and taught.

For several years he was an instructor at
the Famous Artists Schools in Westport,
Connecticut, where he eventually became
Supervisor of the painting staff, with addi-
tional responsibility for many of the teaching
methods developed and employed.

He presently lives in Stockbridge,
Massachusetts, in a hill top house that he
and his wife Florence built entirely with their
own hands. It includes a gallery where he
exhibits and sells his paintings. Surrounded
by the hills and vistas, the farms and villages
of his native region, he devotes himself to
what the title of a recently published book,
written by him, designates as *The Pleasure
of Painting.*

"No matter how long an artist paints he is
always a student, constantly striving to
improve his ability to observe and his skill
at interpreting what he sees. I like still-life
because it offers me the chance to study, to
spend as much time as I need at the paint-
ing. It's more convenient than land and
seascapes where the light is constantly
changing, or figure painting where the model
gets tired. Furthermore it can be done at the
artist's convenience, day or night, in the
comfort of his own studio where he can
control the light and the arrangement of
the subject.

"I also have a great affection for the
things I put into my still-life paintings. They
are usually objects with which I've become
familiar. They are sort of an album of old
friends and through the experience of
painting them I know them even more
intimately.

"This box full of various antique artifacts
and utensils comes from a barn in New
Hampshire. As given to me it contained
perhaps two dozen things to choose from.
Although I had never seen these particular
objects before they were immediately
familiar because they represent the nos-
talgic, rural, mellow subject matter with a
New England flavor that I like.

"I spent an entire afternoon selecting and
arranging the pieces that I wanted to paint.
Since I knew that I was going to be working
seated at my drawing board I wanted them
at a convenient and appropriate eye level,
so I set them up on a couch which served
as a kind of table and made it possible to

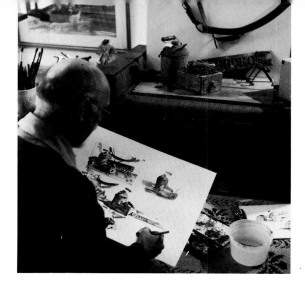

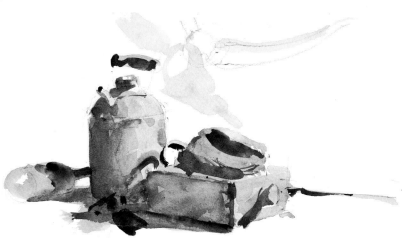

drape a backdrop behind the arrangement.

"From the beginning I particularly liked the rusty old sign. It's good to decide on a center of interest in composing any picture — something that's going to dominate the theme and hold it all together. I began to visualize my composition as building around the firmly geometrical shape of the sign. To accommodate its long horizontal rectangle I decided that the format of the picture — that is, the panel on which it was to be painted — would also be a long horizontal rectangle.

"The preliminary sketches indicate some of the stages I went through in trying various arrangements. One of the first I did shows an old feed bag, but I found its soft form a little vague. So I went back and began re-arranging again. This time I put in the kerosene can, which I prefer as a more interesting and identifiable form, and I eliminated the bag. What I keep looking for, of course, is interesting shapes, especially in the darks and lights that are determined by the cast shadows.

"In this way, after much trying and chang-ing and trying again I came to the point where I was ready to do some wash studies and see what I had on paper. Here I was emphasizing the strong silhouette shapes which are determined to a large extent by the lighting. I set up a flood lamp, low and to the right, to give the kind of raking light that might be coming in through the window or open doorway of a barn.

"With these wash sketches I was still moving things around, changing the arrange-

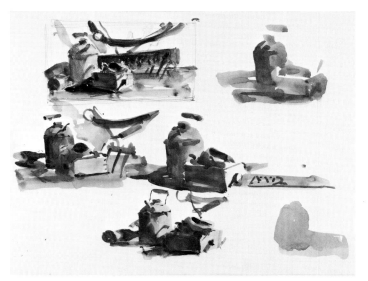

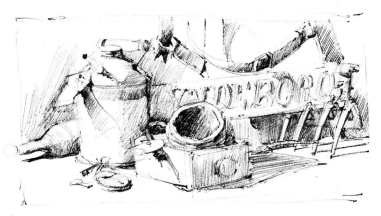

A pencil drawing on the gesso surface places the objects on the panel, which is slightly larger all around to allow for some change in proportions or size if needed later.

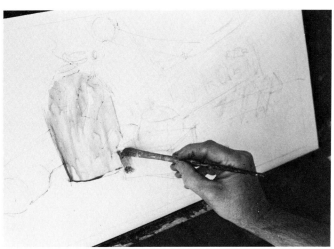

The next step is to establish the relative values. These are built up of nearly transparent washes of a neutral brown.

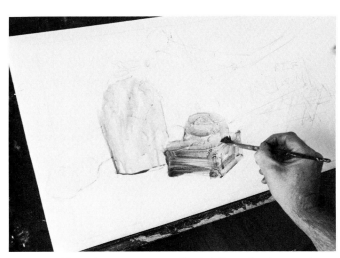

There is no concern with details, only shapes at this stage.

34

ment and trying my hand at various tonal plans to decide very quickly whether I'd be seeing the silhouettes and shapes I wanted. I also did a couple of quick charcoal notes — thinking sketches. Altogether these studies helped me determine how to combine the objects to get the big shapes that are the main elements of the composition. When I finally felt that the arrangement was as harmonius and well organized as I could make it — that is, it was consciously and conscientiously structured, but at the same time had an easy, natural look, not too stiff or formal or symmetrical — I made a more careful little pencil and pen sketch, about 3 by 6 inches. Here, you'll notice, I've changed the light source: it's coming from the opposite side than it is in the final painting.

"My choice of medium for this painting was acrylic. Since most of the forms are small and they have such a variety of textures — the straw of the bird's nest, the wood, the different metal surfaces — I decided that the opacity of the acrylic would allow me to work one stroke over another and so build up the small shapes and all the detail. I sometimes work in watercolor, but I don't like to use it in this way. With watercolor I would be working for a looser treatment. I would be more concerned with the big shapes than with textures. Or, I suppose, I could just as well have used oil paint. It's just that I find acrylic convenient for this kind of detail work. Medium in itself is not the important thing. What does matter is how easily or satisfactorily you can control the particular medium to achieve the result you're after.

I work quickly to get the whole panel covered.

"So I chose acrylic for this still life. It's painted on a masonite panel — the untempered kind that's not impregnated with oil. I prepare the surface wth four or five coats of acrylic gesso. And I put one coat on the back to keep the panel from warping. I usually make the panel a little over-size to allow for any changes I might want to make in the arrangement. The completed panel can always be cut down to exact size when it's ready for framing.

"I do my preparatory drawing with ordinary lead pencil directly on the gesso panel. I work both from the set-up and from the little preliminary pencil and ink sketch. The sketch helps me in placing the objects in their relative positions in the composition. By the simple process of dividing the sketch and the panel into a corresponding number of squares I assure myself of keeping the same arrangement in each step of the picture's development.

"The pencil stage is just an outline drawing to indicate the shapes and sizes of the objects and their positions. It isn't necessary to carry the drawing any further because I'll be building up the form and detail as I paint.

"My next interest is to establish the big over-all value pattern. I begin painting with thin transparent washes, almost as though I were working with watercolor. But I also scumble on color with a rather dry brush in some places, particularly in the darker areas and where I want the brush work to suggest textural surfaces. Where there's wood grain showing, as, for example, on the side of the box that holds the bird's nest, I use a brush stroke that follows the grain.

"I work over the entire painting with these

Next I begin to consider the light and shadow areas.

I can use my fingers as well as the brush to move the paint around.

35

The blocking-in process continues. Everything is painted with a broad brush.

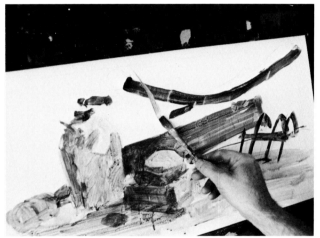

Darker areas require more pigment, but washes are still kept thin to retain a smooth surface.

broad washes and scumbled darker tones, building up the big pattern of darks and lights. Once that has been firmly established I know that whatever I do in the way of modeling and detail, my picture is going to hold together as a coordinated, structured composition.

"Even when I get further into the painting I continue to work with thin washes in order to keep the smoothness of the ground surface. If I were to use heavier pigment it would dry with little bumps and ridges and I'd have difficulty working over them with the fine brush strokes that I use in the later stages. In the event that the surface should

begin building up in this way in places that I want to keep smooth I sandpaper it back down to the gesso ground, unless, of course, a certain area calls for a rough surface.

"While I'm laying in the broad areas of the painting, and even later, developing the detailed forms of the individual objects, I'm not giving much attention to the final colors. I'm working with a fairly monochromatic palette that includes umbers, raw sienna and yellow ochre. In the initial lay-in I use very little white, but as I get into modeling and building up more opaque areas of over-painting the white plays a more important part.

36

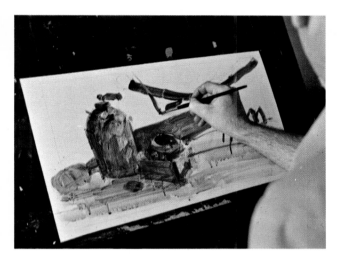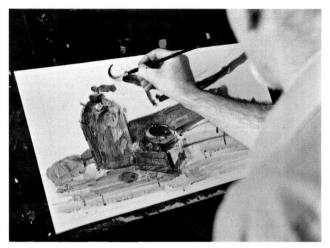

All parts of the picture are painted with the same monochromatic palette at first.

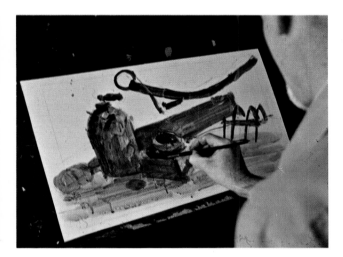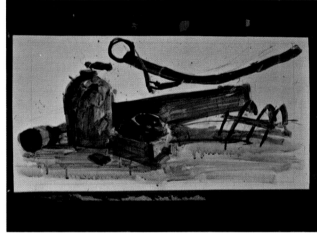

With the completion of the bird's nest, the whole painting has been laid in.

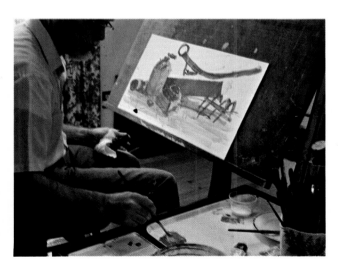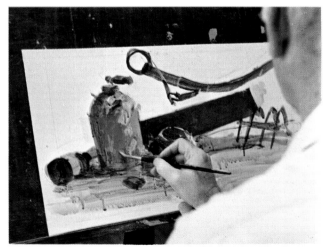

Now, for the first time, I begin to consider local color, mixing and applying the bluish-gray coloration of the kerosene can.

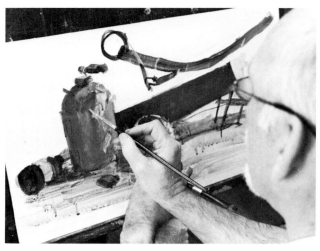 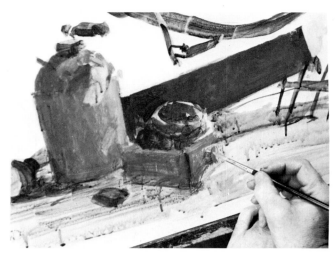

The addition of white to the pigment makes it opaque.

The pigment now has greater covering power, but I still keep it diluted and thin.

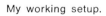

My working setup.

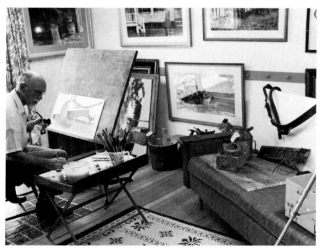

"Color comes later, as the painting develops to an advanced stage. Again I'm working with thin over-washes, but now they are glazes of color. In doing the kerosene can, for example, I wash a tone of yellow ochre over the monochromatic under painting. Over that I work with fine brush strokes and opaque white, modeling the form. When this is dry I put on several loose washes of blue which allow the yellow ochre to show through in some places and the white in others. The former convincingly suggests the patina of the old can while the latter gives the effect of dully shining metal.

"The background, which I visualize as a rough textured plaster barn wall, receives a similar treatment. It would be possible to

38

Accents of darker values help to define the forms.

 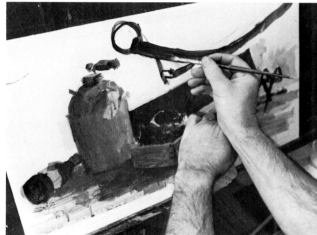

Now I begin refining the shapes, cutting back or adding to them.

Brushes are kept immersed in water when not in use. Dried acrylic paint is insoluble and ruins the brushes if allowed to dry in them.

The spacing of the lettering on the sign is plotted out on a strip of matboard.

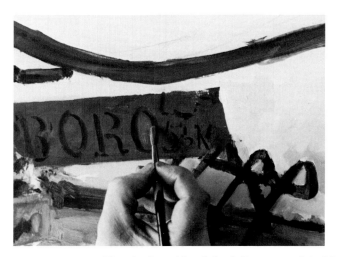

The shadow side of the letters are painted in first. Next, the light areas of the drawer, nest, and sign receive attention.

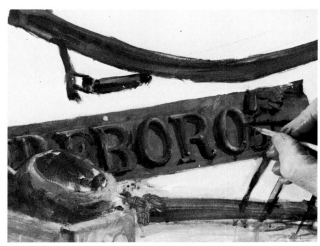

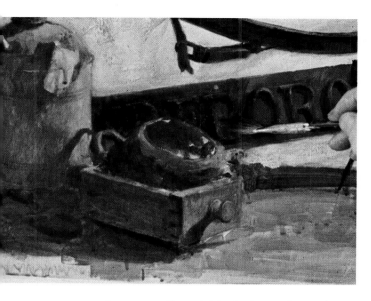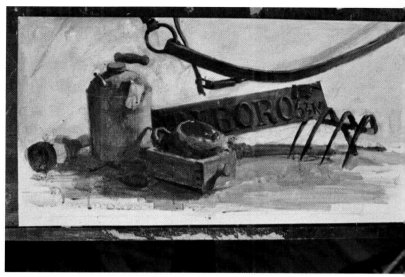

As soon as the paint is dry I can glaze a transparent shadow tone over the sign, while still retaining the drawing of the lettering.

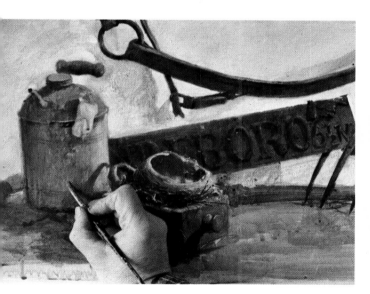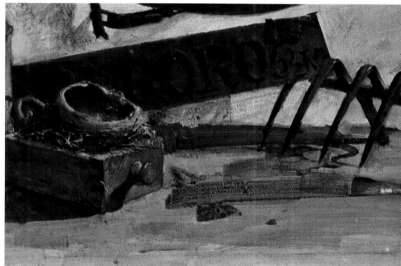

By alternately adding either an opaque or transparent pigment, the colors and values are gradually built up, while the painting is kept under control at every stage.

I continue to work over the entire picture rather than finishing the elements individually.

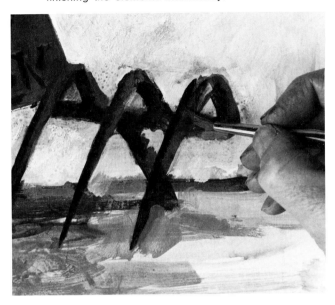

carefully paint in all the bumps and stains and irregularities characteristic of such a wall with a small brush and many careful strokes but that would take a lot of time and effort. Here it is less laborious and just as effective to simulate the roughness with pigment, brushing and dragging on a heavy application of white and manipulating it with the brush so that it actually forms a rough surface. This I do with the foreknowledge that I'll be glazing with transparent layers of color which will cover the crevices and rough spots and so complete the appearance of an old wall. Then any changes or adjustments that should be needed can be added with opaque overpainting.

For the first time, heavy pigment is applied to simulate the texture of a plastered wall.

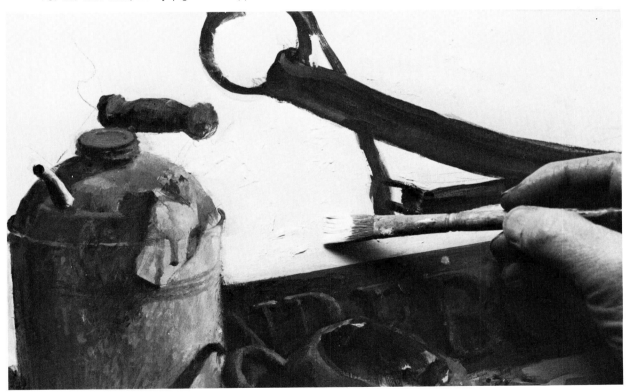

42

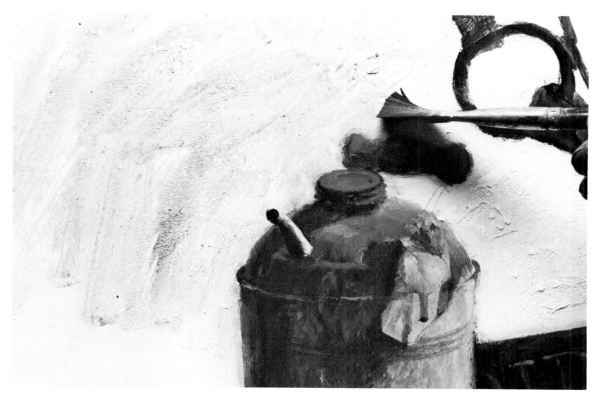

A thin wash of tone is applied over the white wall, then partially lifted off with the brush or blotted out with a cloth to simulate the patina of age.

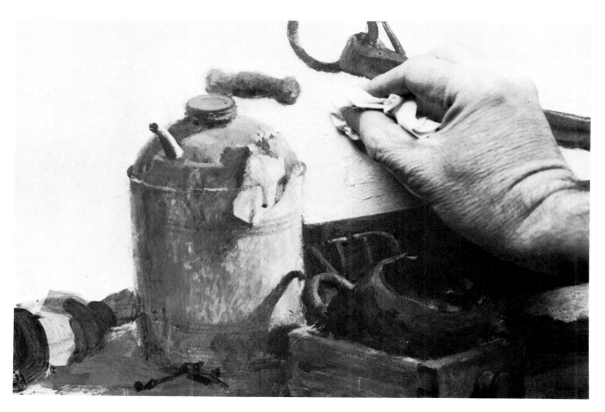

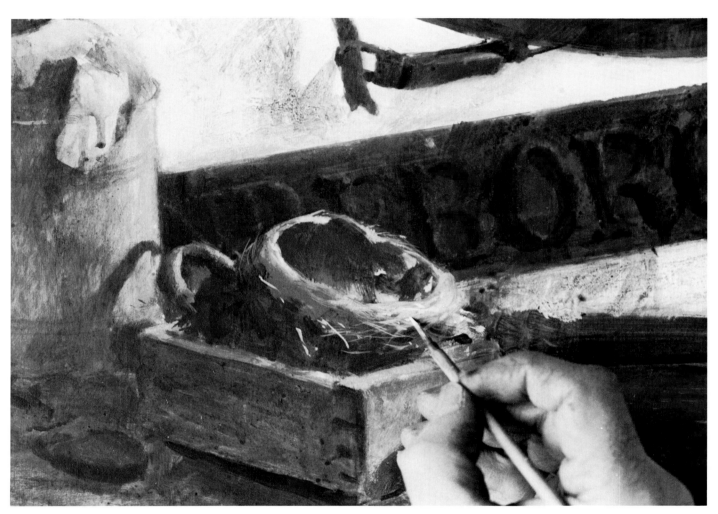

As the center of interest, the nest receives special attention.

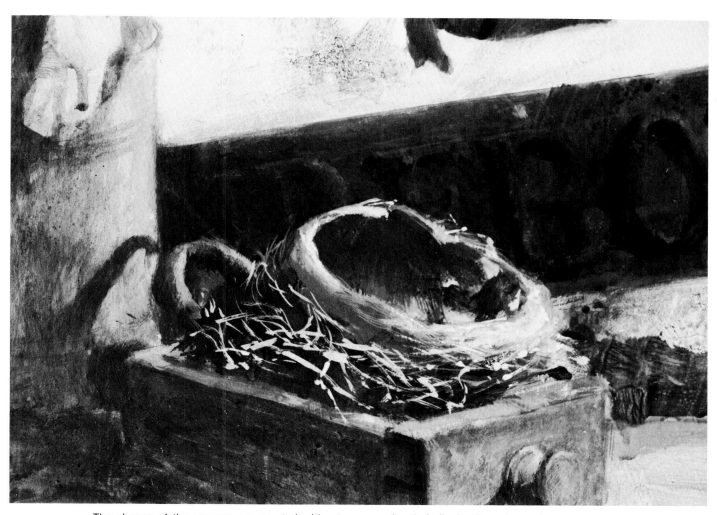

The shapes of the grasses are created without concern for their final value, since glazes will selectively place some in shadow or change their local color.

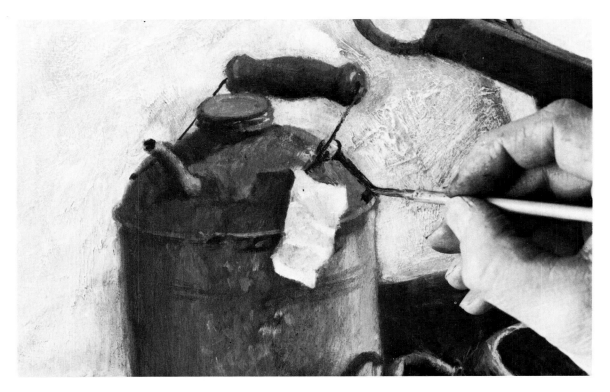

Finishing details can now be completed, such as the key and tag on the kerosene can and the padlock and keys in the shadow area of the drawer.

These transparent color glazes, warm or cool as the subject and the light suggest, are the final act. Where it seems to be called for I paint into them, correcting details, making the little changes that complete the painting.

The last thing I do is varnish the finished painting with several coats of acrylic matte varnish, each coat diluted with a little water.

Although the painting has been completed out to the edges of the gesso panel, I revert to my original proportions by simply sawing off the unneeded areas.

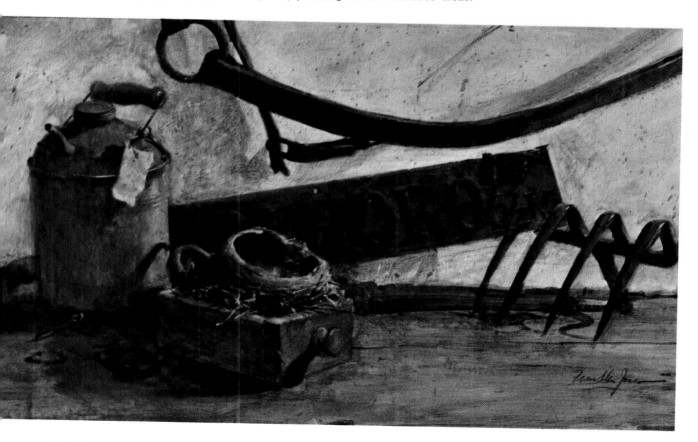

Barn Swallow's Nest

3 BERT DODSON

The artist in his studio

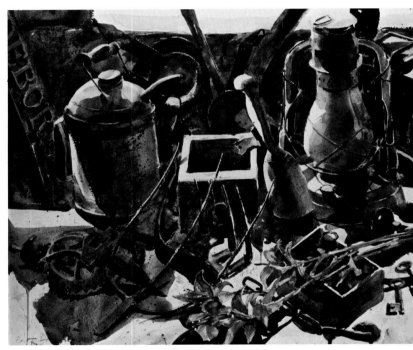

His watercolor still life

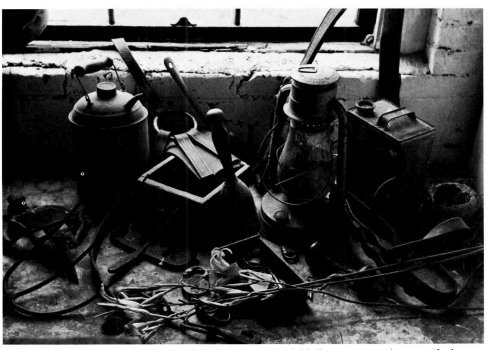

The challenge is to make an organized picture of what initially appears to be a confusing jumble of miscellaneous objects.

Bert Dodson has been solving problems of image making and design in a remarkable variety of forms since he was an undergraduate at the University of Arizona working part-time for an ad agency and as a free-lance artist.

In addition to doing everything from layout, illustration and animated story boards to a 200 foot mosaic mural for a shopping center he has, throughout his career, independently given expression to his personal vision as a draughtsman, graphic artist and painter.

Before leaving his native West to live and work in New York and eventually in Connecticut he had one-man exhibitions in Phoenix and San Diego.

He was co-founder of Creative Partners, Inc.,a graphics and film-strip studio in Westport, Connecticut. Since 1971 he has illustrated many books for a number of New York's foremost publishers. On top of commercial assignments, free-lance painting and graphics, he has taught at the Silvermine College of Art and is currently teaching at the Fashion Institute of Technology in New York.

In painting a still-life for this book he chose to use all the objects presented to him rather than just a few. He set them in full sunlight to create a complex shadow pattern and then, having given himself what many artists would consider an extraordinarily difficult problem, he successfully solved it with grace and apparent ease — a performance that eloquently demonstrates this artist's consummate skill.

"Given a batch of objects from which to choose those I'd like to paint, I took them all.

"I'm interested in painting and drawing very complex, active surfaces with lots going on. This relates to my interest in film. A moving picture film is actually a series of images, or frames, which rapidly pass before the viewer's eyes. I found that when I make a drawing or painting composed as an intricate all-over pattern of images, whoever looks at it has to organize it in his own viewing because he can't take it in all at once. We can focus on only a limited area at a time. The eyes move from one part to another, taking in each separately, sorting out and organizing in a flow that I equate with the flow of images made by a motion picture film projected on a screen.

"The result is a challenge to the viewer because it takes time and concentration to look at this kind of a complex, active picture.

"As to arranging these objects and implements for my painting I deliberately developed a casual, bunched-up grouping. I placed them all in a window where direct sunlight falls on them. The fact is that almost any combination and arrangement of all these things, plus the way they break each other up with their overlapping and crowding, plus the strong light and shadow, makes exactly the kind of busy all-over pattern of many intricate shapes that I'm after.

"I want to maintain the individual identities of the objects so that they're clearly recognizable, but I also want the multiplicity and variety of shapes that is gained by their overlapping, their partial concealment and

50

In the preliminary charcoal studies I explore a variety of approaches. Here two objects,
the lantern and the pestle, have been expanded into a multiple image.

— while below everything has been laid out in an all-over pattern that fills the picture space.

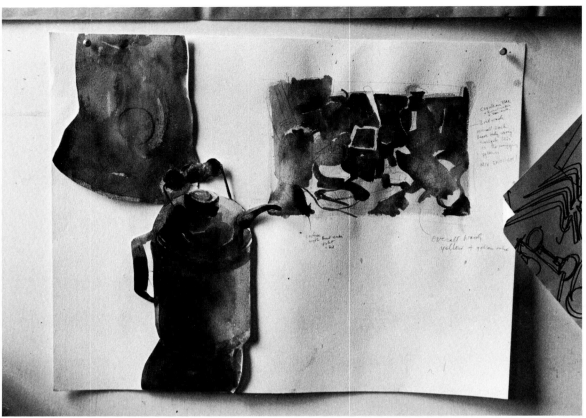

A thumbnail sketch and some detail studies convince me that watercolor is the appropriate medium for this particular still life.

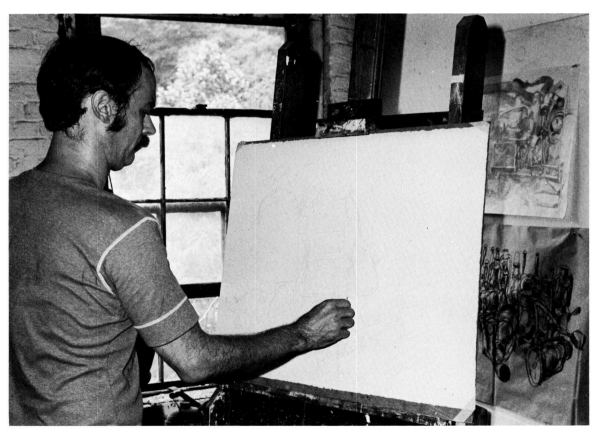

The intricate shapes and complicated patterns of the subject call for a careful pencil drawing on the watercolor paper.

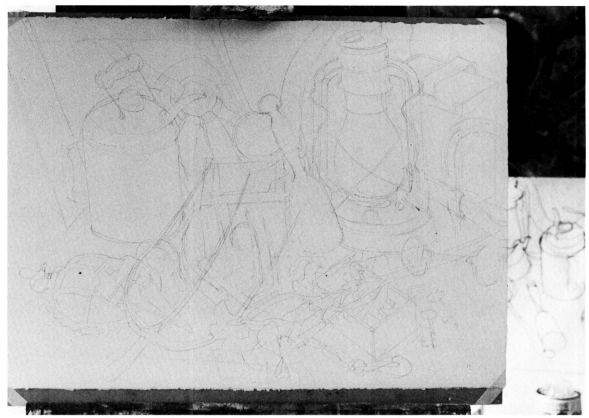

The drawing indicates shapes, scale and placement of the objects without going into modeling and cast shadows.

the shadows they throw across each other. In this way I establish a basis for the complex, active surface that I will be developing in my painting.

"I work in a lot of ways and mediums. In this project my choice is watercolor. The kind of problem I've given myself here may not seem altogether sympathetic to watercolor, but I have a little different attitude toward this medium than a lot of artists. I like to work for spontaneity and to me this means responding from moment to moment to what I'm seeing and what I'm painting. This often involves a lot of changing, a lot of altering, a readiness to shift direction. I'm going one way and something happens in the painting so I take a cue from that and act accordingly. Or the light changes and I redefine a passage. That, to me, is spontaneity.

"I treat watercolor the same way I do a lot of other mediums. That is, if I feel a need to resort to opaque, or pastel, or even to cutting out shapes and mounting them on another piece of paper, I'll do it. I don't make big distinctions between one medium and another. I can only work by a series of responses to the immediate problem.

"Because there are so many intricate shapes in this picture I feel the need to begin with a rather careful preparatory drawing. This I do with pencil directly on my sheet of watercolor paper, concentrating on the placement and the descriptive shapes of the various objects and not trying to firmly establish the pattern of cast shadows at this stage. In working with watercolor I have to draw the shapes more carefully and clearly than I would if I were working in some other medium because I can't restate areas and

Earth colors predominate — yellow ochre, raw and burnt sienna, raw and burnt umber. I have no fixed rules for setting my palette.

A flat house painter's brush for my first broad wash, which is a golden yellow tone over the entire paper.

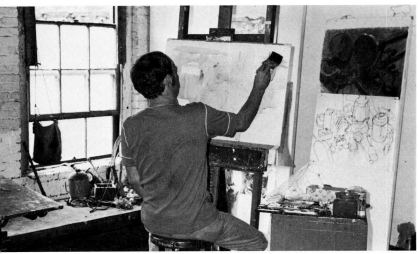

Next a second wash, darker and cooler than the first.

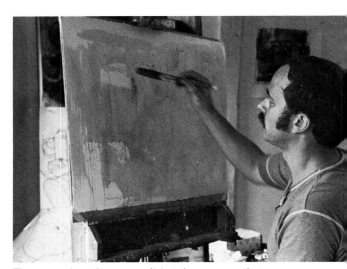

The second wash covers all but those areas that will be light in the finished painting.

re-establish boundaries in the painting stage as easily as I could if I were working with opaque pigments.

"In setting out my palette I have no regular system. This subject has a lot of browns in it so the earth colors predominate, particularly ochres, umbers, and siennas. My first wash is a golden yellow over-all tone with which I cover the entire paper, using a large, flat housepainters' brush. In a few places, where I know that I'm going to want very light areas, I lift off the wash before it dries by tamping it with a piece of damp cleansing tissue.

"The next application of color is another broad wash, this one considerably darker and cooler than the first. It covers all but the places that will be light in the finished

picture and gives a unifying effect. It's basically a mixture of Prussian blue and raw umber, but there's a rusty tonality to many of these old objects, so I also begin to introduce bits of red and alizarin crimson. While I'm putting on this second wash it seems very dark in contrast to the yellow, but watercolors become definitely lighter as they dry and this should be kept in mind while you paint. In fact the second, darker wash ultimately will be the lightest of the shadow tones.

"Often I dip the wet brush into several colors without mixing them completely on the palette because I like the color activity that takes place as they run together, mingling and fusing on the paper.

Left. I don't hesitate to mix mediums where I feel the need. Pastels, crayons, magic markers, all are legitimate if they help make the picture successful.

Below. A golden all-over wash sets a mellow tone and pulls the whole arrangement together.

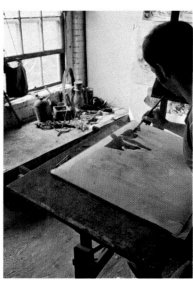

I next carefully paint a dark, cool wash over all of those areas or objects that will be in shadow.

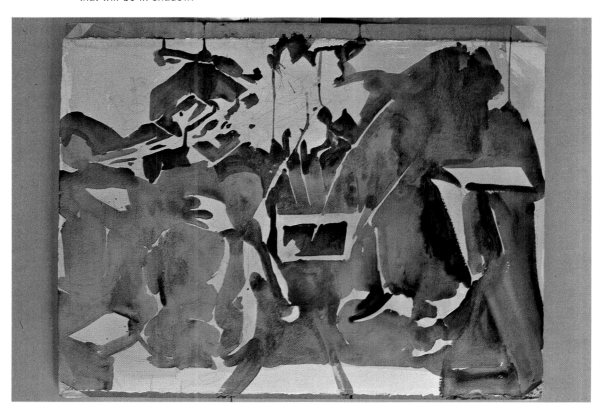

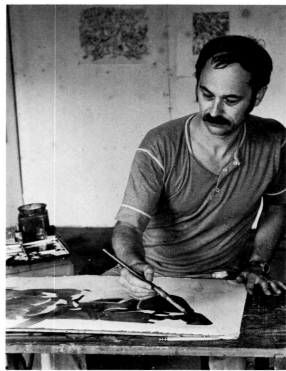

Identity of the various shapes and the pattern made by their arrangement emerge as I begin to put in the darks.

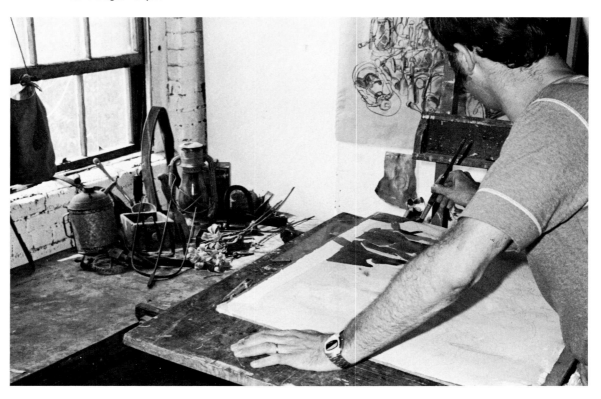

The dark tones are heavier and drier (more pigment and less water) than the initial washes. Consequently they don't lighten so much in value when they dry.

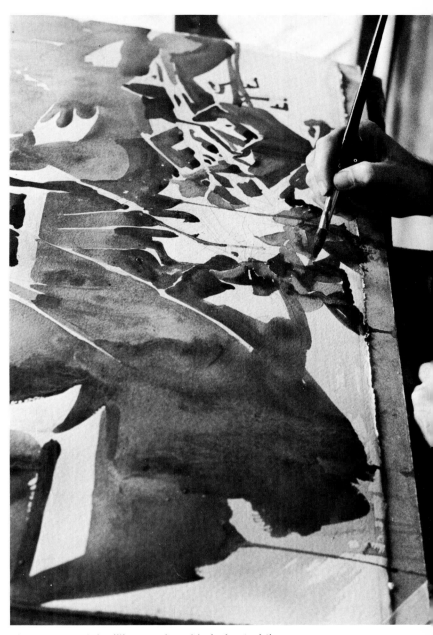

The purpose of the lilies, on the table in front of the lantern, is to add a bright note to a color scheme that is otherwise somewhat somber.

"I've introduced some day lilies in the foreground as an excuse for a bright spot of pure color. As I paint them in I carry them well along toward completion because they represent the strongest color I'll be using and I want to establish the full range of intensity as a point of reference. I know that everything else I do will be subordinate in strength to the orange of these flowers.

"The next step is to establish some strong darks — the darkest values of the painting. As I paint them in I'm also reinforcing the drawing, clarifying it by defining and separating many of the smaller shapes. I use rather heavy pigment, more paint and less water, to mix this tone. This drier, heavier paint mixture doesn't change to a lighter value when dry nearly as much as the previous, wetter washes.

57

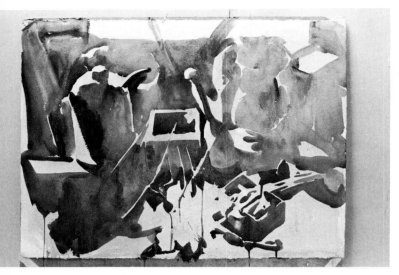

Over the broad cool washes I apply transparent tones of warmer color using washes as well as dry brush.

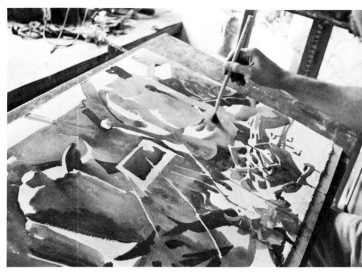

My only planned procedure is to keep building up halftone and dark areas until form and pattern take complete shape.

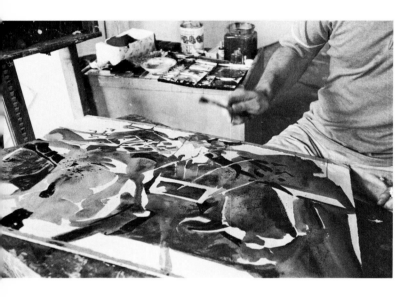

Judicious use of spattering with a sponge and brush can add textural interest.

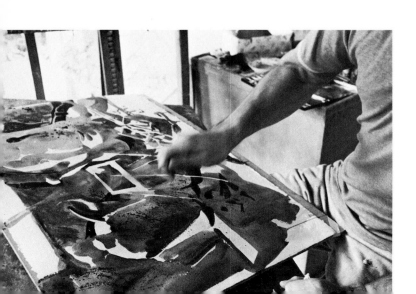

"From this point on I don't adhere strictly to planned procedure, but take my cues more and more from what I've already painted as well as from what I'm looking at. It becomes more a subconscious exercise, although every once in a while I do consciously pause to organize my thinking and see where I'm going.

"As I've said, that second, all-over shadow wash contains Prussian blue mixed with raw umber to suggest hard, cool metallic surfaces. But now as I develop the rusty, antique color and textures that predominate I superimpose some warmer tones — siennas, oranges, burnt umber, a little alizarin crimson. I do this with washes, with spattering, with dry brushing. And for certain rough, textural effects I flick on spatters of sepia and umber with a large watercolor brush, letting the paint fall where it will. In any places where I don't want the splatter to remain, such as a high light area, I wipe or blot it out while it's wet.

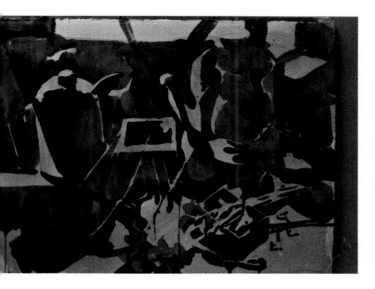
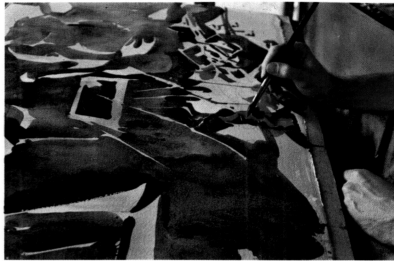

The lillies were added to introduce some color and a focal center.

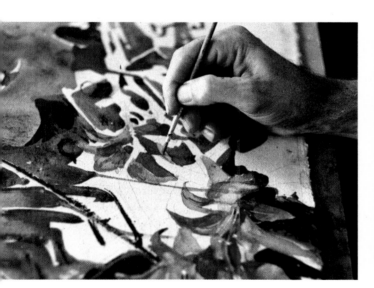

In addition to the watercolor pigment, the color is reinforced in some areas with crayon.

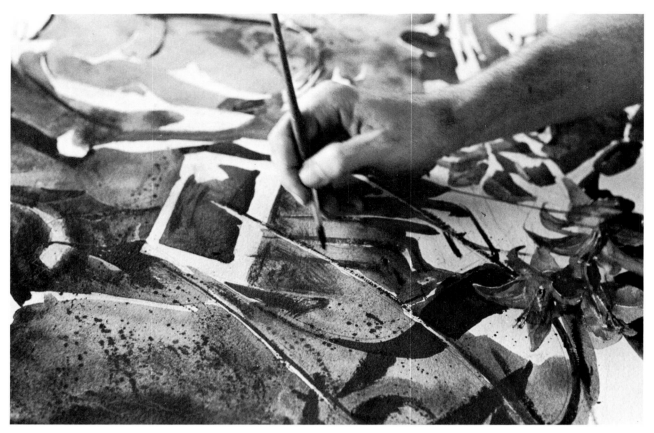

To keep life and sparkle in shadow areas I overpaint after the dark wash has dried, introducing touches of alizarin crimson, cadmium red and cerulean blue.

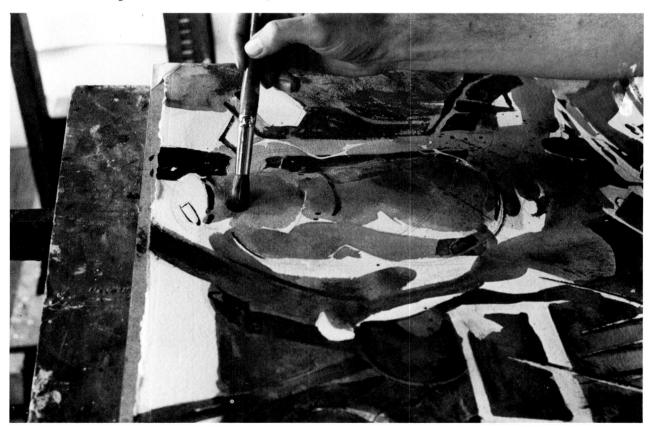

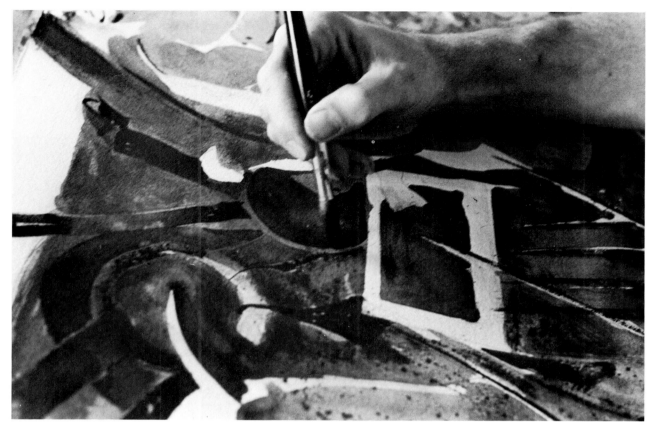

The addition of bright colors to dark areas blends harmoniously if the more intense hues are close to the shadows in value.

The addition of some white to the pigment makes it opaque and permits changes or additions over areas already painted.

"At a certain point, when all the washes are dry, I do a little redrawing with pencil where some of the finer lines and smaller shapes are getting lost. After that it's largely a business of continuing to build and shape the darks. I keep attempting to infuse life and excitement into the shadow areas by adding color. Here I use alizarin crimson, cadmium reds, some cerulean blue. These are colors that are quite strong in hue but they will take their cohesive place with the shadows as long as they are dark and close to them in value.

My feeling is that watercolor is best used as a spontaneous medium and that it should never be overworked. My main concern in getting into the details is that they not become over-rendered, but be done as freely as the larger elements.

"As the painting progresses the pace at which I work changes. In the beginning, putting in the broad washes, building them from light to dark, it went rapidly. But now that the paper is covered and the whole big pattern of darks and lights, of form and shapes and space has been pretty much worked out, the problem is one of finish — of what to emphasize and what to leave

For the same purpose of maintaining spontaneity, I try to use the most direct means to
a desired end. If a stroke of a marking pen or even crayon or pastel will work more
effectively than transparent watercolor, I do not hesitate to mix media. Neither do I
differentiate between transparent or opaque watercolor, using whichever will best produce
a particular effect I'm after.

alone. As I work from one object to another
I must be careful not to over-render any
one without logical relationship to any other.
These considerations may be automatic to
a certain extent but nonetheless they also
call for deliberation and careful attention to
detail. As a result I'm compelled to work
slower the further along I get.

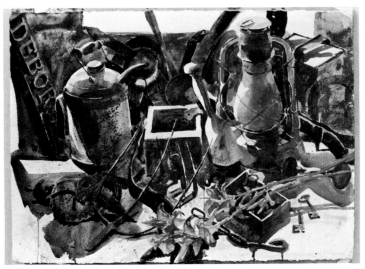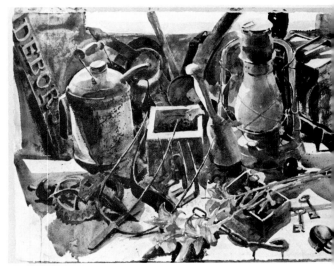

The extreme lower right corner of the paper, in comparison to the entire active surface, is empty. As a final touch I fill it with a padlock.

When looking no longer calls for doing anything the painting has to be finished.

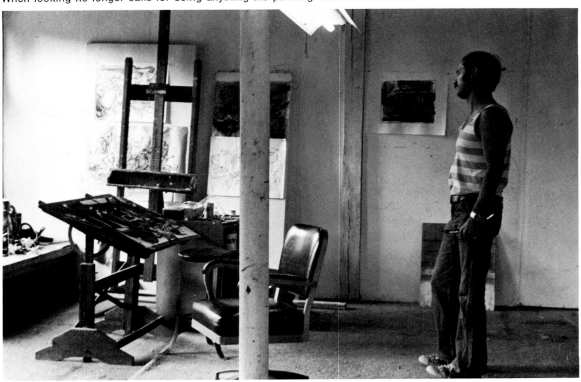

"In the end I use a razor blade to scratch out some high lights here and there, such as on the lantern and the tines of the pitch fork. I add some opaque white, which I float in a dilute mixture over the glass of the lantern to give it a low key highlight. And I use some wax crayon, especially on the flowers where I feel that even more intensity of color is called for.

"The business of knowing when the paint-

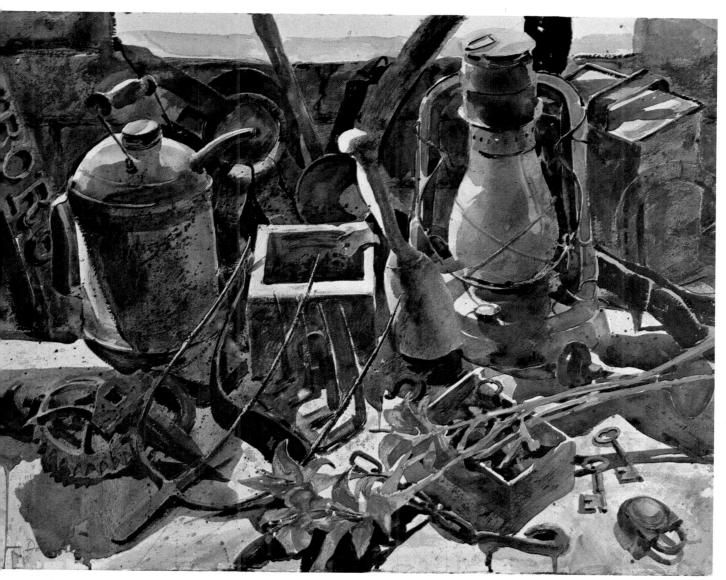

Grandpa's Things

ing is finished is difficult for me, as it is for many artists. I suppose it's when you can't think of anything more to do that will make the picture any better. The essential problems are solved."

4 ENID MUNROE

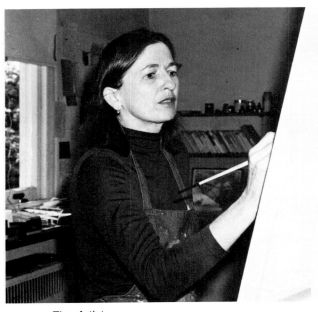

The Artist

Her still life arrangement

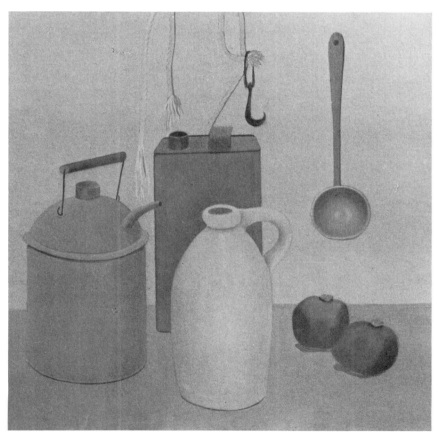

The finished painting

My preliminary sketches are simple diagrams that make use of lines and words to help clarify my thinking and planning.

This sketch suggests the general color scheme and the structure, rhythm and movement of the arrangement.

Some artists regard still-life painting as a studio exercise, or a convenient way to observe and work from nature — convenient because the raw material for the picture motif usually consists of readily accessible objects that, once selected and arranged, can be counted on to remain immobile until the picture is finished.

Enid Munroe's involvement with still-life painting is more profound. It embraces, in addition to the plastic considerations indispensable to all picture making, social, historic and philosophical implications that transcend the merely visual. There's more here than meets the eye. Those serenely realized jugs and bowls and household implements pertain to humanity. They symbolize the unity and continuity of mankind.

The formal training received at the Grand Central School of Art, the Art Students League of New York, and the Silvermine Guild School of Art she evaluates as important in her development, but nonetheless secondary to the influences and lessons of travel and the study of a variety of cultures, particularly that of the Orient. She has lived and worked for extended periods in Europe, Mexico and the Far East. Her present work and the thinking from which it evolves owe much to three years (1970-73) spent in Japan.

She has had more than a dozen one-woman exhibitions, including two highly successful showings at New York's FAR gallery, and is a frequent contributor to group exhibitions in New York and New England. Her paintings hang in the permanent collections of several major corporations and in many private collections. She is a member of the Silvermine Guild of Artists and the Connecticut Academy of Fine Arts.

"The idea of still-life is a reoccurring concept in the collective consciousness. In Egypt I saw wall frescoes of fruit and vegetable offerings that were painted thirty-five hundred years ago. And in Japan I saw a beautiful Shinto ceremony in which baskets heaped with exquisitely arranged fruit and vegetables and fish were placed on an altar by thirty priests.

"I'm involved with a reinvestigation of still-life painting. The still-life motif is conspicuous in the work of Chardin, Cezanne, the Impressionists and Post Impressionists but I feel that this aspect of painting has been neglected in the present century.

"The fruit, vegetables, flowers and objects an artist paints are universal symbols, and

68

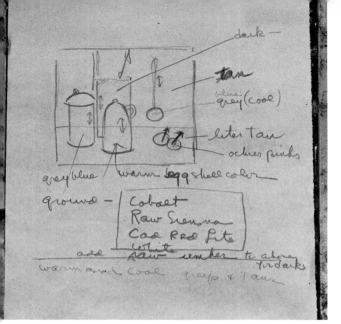

A more detailed notation of color distribution and balance of values.

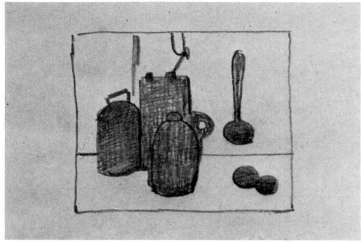

The main elements of the composition and their balanced distribution in terms of mass.

various utilitarian vessels have been part of everyday life in all cultures. They were usually created for functional purposes, not as art or ornament. The fact that they are often beautiful derives as much from their humble honesty, their faithfulness to the uses for which they were created, as from any aesthetic considerations that might have gone into their making.

"So, in considering subject matter for a still-life I don't choose objects that were made for artistic or decorative purposes. I look for the shapes that were made by all men and all cultures. These are basic and universal. There are just so many shapes that can be made on a potter's wheel. Consequently all the people who have used the potter's wheel are related through their shapes, their forms, even the colors of their glazes. The same is true of basket weaving, where the materials and tools to a large extent determine the form. Even the table on which the still-life is set up is a basic object — four straight legs and a flat top, without any frills or ornament to identify it as belonging to a certain period in time.

"When I arrange the set up, I assemble a number of objects — usually a good many more than will be selected for the painting — and then I eliminate until I have the shapes

and combination of shapes that I want. I like the arrangement to have a careless, spontaneous look, as if it had been there for a long time or someone had just come in and left these things and is coming back at any minute. This is a still-life, yes, but it should nonetheless suggest the human presence.

"In making the arrangement for this painting I've introduced a couple of pieces of rope into the composition. Rope or twine can be thought of as another utilitarian universal — something that has been common to all mankind since prehistoric times. To the artist rope, twine or string can also be useful as a device for describing space. Depending on how it is placed in the picture it can make the eye move up or down the canvas, or across it from side to side. It can help indicate a rounded surface by its curves or a flat plane by its straightness.

"My objective in painting these things is not just to make another pretty picture but to get in touch with latent and unaroused feelings in the viewer, to awaken responses to something more than mere decoration, and perhaps to get people to look at ordinary, commonplace things and think about them in new ways that are not ordinary and commonplace.

69

After the canvas has received two coats of gesso I cover it with a flat base color consisting of a mixture of raw sienna, cadmium red light, cobalt blue and a considerable amount of white. Three or four coats give a perfectly flat all-over tone.

"When the things that I'm going to paint have been placed in an arrangement that finally satisfies me, I make a number of little thumbnail sketches that help me visualize exactly how I intend to translate what I am looking at and thinking about into a fully realized painting. These sketches and the notes that accompany them record information pertaining to color and values and to such considerations as the tensions, rhythms, balance and directional movements inherent to the composition.

"Meanwhile I have prepared the canvas on which I'm going to work by giving it two coats of gesso, sandpapering each after it has dried. Then I cover the canvas with three or four coats of a flat base color (I use acrylics) that I make by mixing yellow, blue, red, and white. For example this might be a combination of yellow ochre, ultramarine and red oxide, or — as in this case — raw sienna, cobalt blue, and cadmium red light.

"I do a careful outline drawing with charcoal on the toned canvas, working directly from the set up. This is an important step because it's where I work everything out precisely as it's going to be in the painting. I don't like changing and rearranging after I've begun to paint.

"The first line I put down is the horizontal that marks the back edge of the table top. This is a line that still-life painters can hardly ever do without because it places the subject by indicating where it is in space. It corresponds to the horizon line in a landscape. In some paintings I might blur it out, almost get rid of it, but it's always there at the beginning of my drawing.

70

The line drawing in charcoal, on the toned canvas, is done with care and precision. This assures against having to make changes after I begin to paint.

The placement of each linear element — vertical, horizontal, curve — is determined with consideration not only for every other line but for the negative areas between the objects.

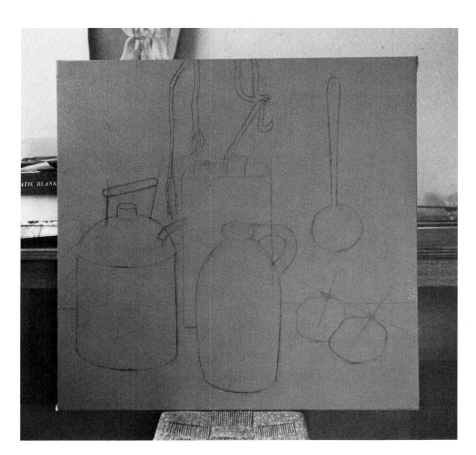

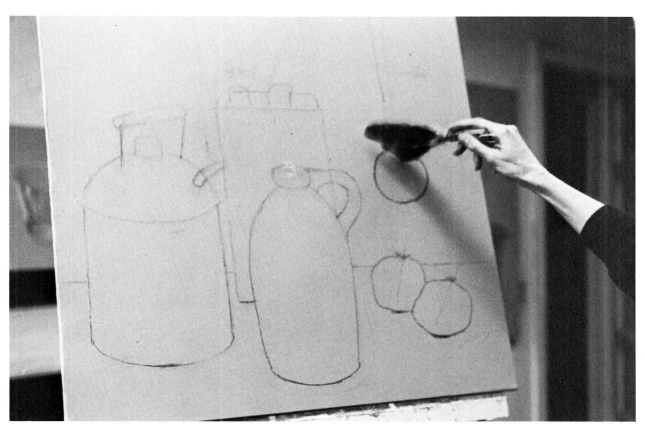

Dusting the loose charcoal off the finished drawing.

"After that critical horizontal the next lines are the verticals, beginning with the side of the jug that's next to the left edge of the canvas. These verticals aren't necessarily parallel. They create tensions by the way they press toward each other in some places and pull away in others. In placing and drawing them I think of the spaces between them and the negative shapes they form. I like a lot of the background to come into the arrangement, so that the colors and value tones of the foreground objects have space and time to play against it.

"While I'm thinking of the linear characteristics of the principal shapes. I'm also thinking of their volumes, their roundness. All the curves are important, the shapes of them, the way they repeat themselves. The elipses at the tops and bottoms of the jugs suggest their roundness but as I draw I flatten them out a little so that they stay on the flat picture plane. I respect the two dimensional limitations of the canvas. I'm not interested in an illusion of deep space. I want to keep the space flat and close to the viewer.

"My linear composition is a geometric structure built on a grid of interrelated horizontals and verticals. I'm very concerned with the architecture of a painting. I want it to be as strong as a cityscape of buildings. None of the shapes can be wishy-washy. This is why I take a great deal of care in doing the line drawing — to make sure the shapes are clearly defined and that they're arranged in structural solidity.

"When I'm satisfied with the drawing I dust off the loose charcoal and I'm ready to paint.

73

The surface of my work table is my palette.

On it I brush a patch of the base color with which the canvas is toned. I can then judge the hue and value of each subsequent color mixture in relation to the background color before applying it to the canvas.

"Many painters begin by first establishing their darkest or lightest areas. I don't. My starting point is with the middle values. In fact the key middle value has already been set by the basic color with which I covered the canvas before I began to draw — the background color. Then, as I paint, I work very gradually from the middle tone toward the darks and lights. The darkest and the lightest are the last to go on.

"I use a variety of brushes that includes the nylon kind made for acrylics, bristle brushes, soft English sables and Chinese watercolor brushes.

"My palette is a portion of the top surface of the work table that stands beside my easel. As I begin painting I brush a patch of the basic background color onto the table and let it dry. I do all my subsequent mixing of colors on this patch so that I can tell how each hue and value is going to look on the canvas.

74

The scale of dark to light and warm to cool is determined in relationship to the base color.

First brush work — reinforcing parts of the line drawing.

75

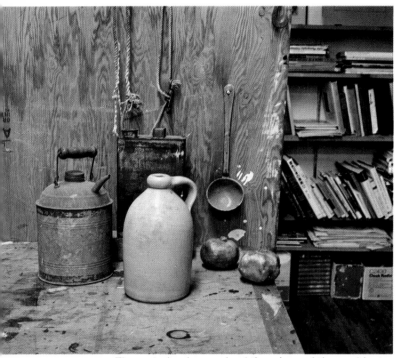

The muted colors and subtle values of these objects are in keeping with the kind of palette I like to work with.

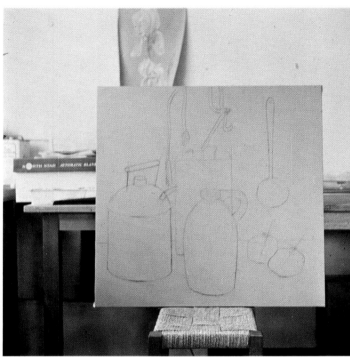

The charcoal drawing is made on the toned canvas.

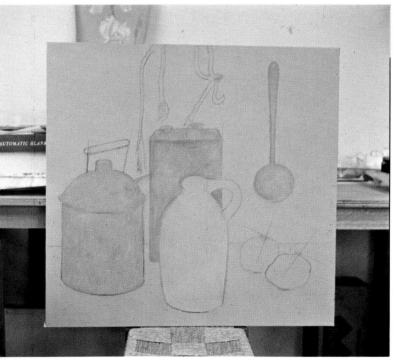

During the lay in, the objects are treated almost like silhouettes.

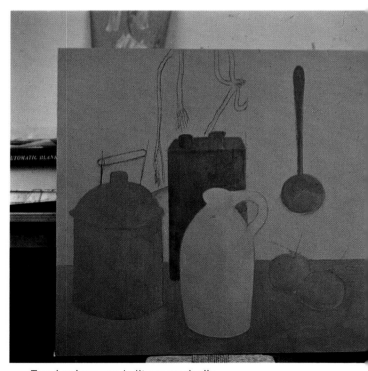

Tonal values are built up gradually.

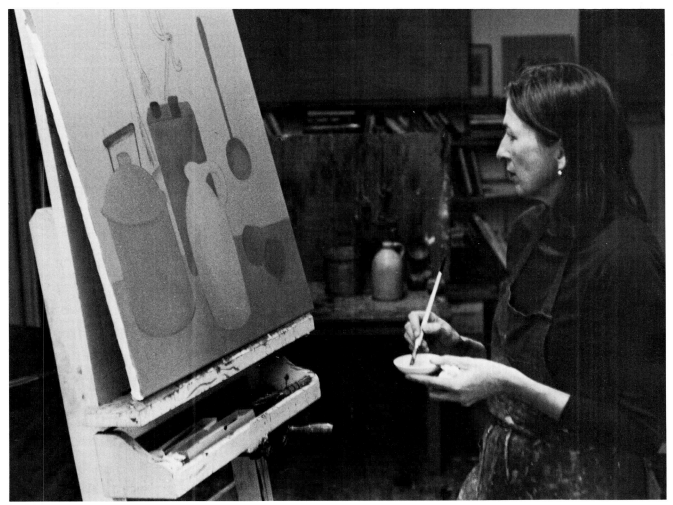

Working from the middle tone of the background I establish the next darkest and the next lightest values, one step at a time.

"The quiet, meditative mood that I'd like the painting to convey calls for an understatement that's achieved with a closely limited range in colors and values. The point is not to arouse excitement but, on the contrary, to engage the viewer calmly with a visual statement that suggests serenity and silent space.

"Another reason I have for maintaining this kind of low key harmony is that holding back a little short of the peak of possibility — that is stopping short of what might be expected — leaves a tension, a deliberate gap between the completed and the uncompleted, that invites the viewer and thereby further involves him with the painting.

77

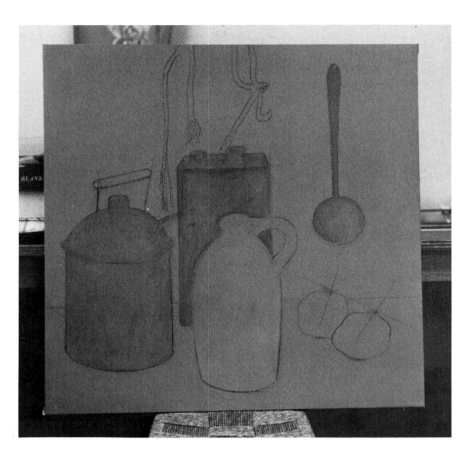

In limiting the range of values and colors I strive to achieve maximum impact with minimum means.

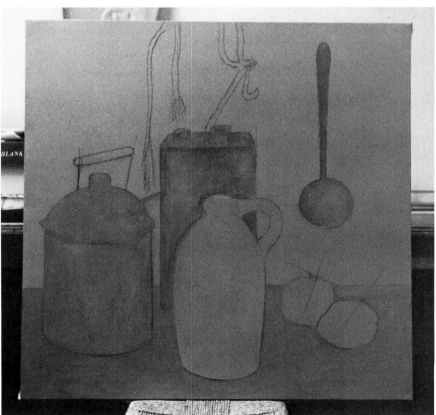

78

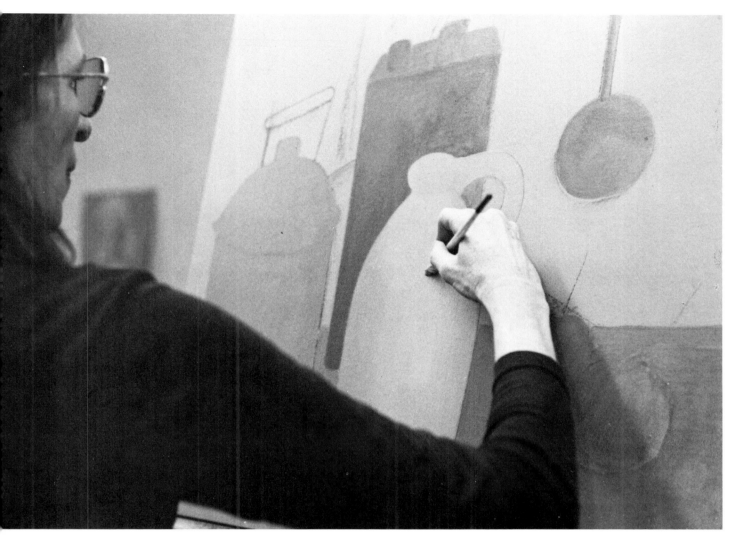

A slow build up of paint — thin layer over thin layer
— for subtlety in tonal variation and a smooth surface.

"So I use few colors — for the most part
variations of the red, yellow and blue that
went into the background, modified with a
good deal of white, and now and then a little
raw umber or raw sienna. Into every mixture
goes a little bit of that background color for
the sake of over-all unity. And sometimes, of
course, I introduce an accent of stronger,
brighter color as I have here with the
pomegranates.

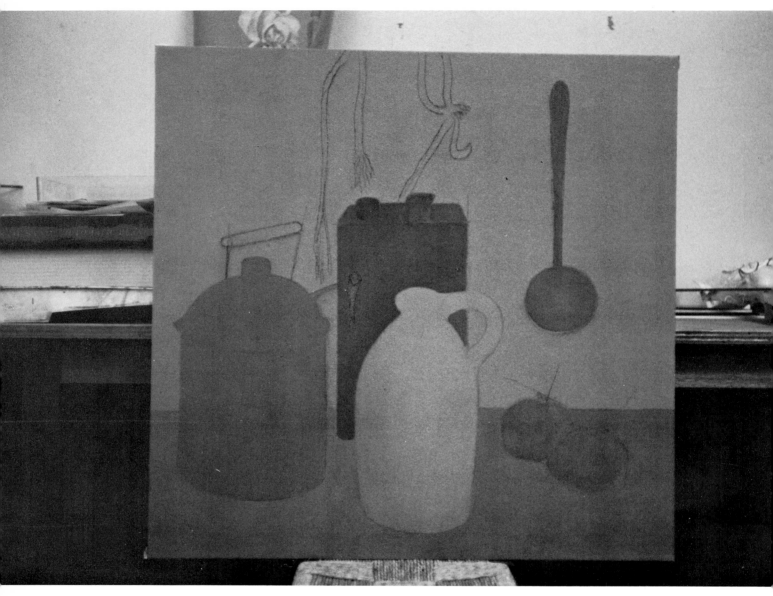

A commitment to the darkest and lightest extremities of the value scale is not made until the middle tones have been satisfactorily established.

"I like to keep a smooth surface that doesn't show any brush strokes and that lets the weave of the canvas come through. I do this by diluting the paint mixture with water and applying it in thin washes or by scrubbing and scumbling. I can't be sure of the value relationships until I get a first coat on everything as a test. Then I go back over the whole canvas again and again, adjusting the subtle differences in color and value, warm and cool.

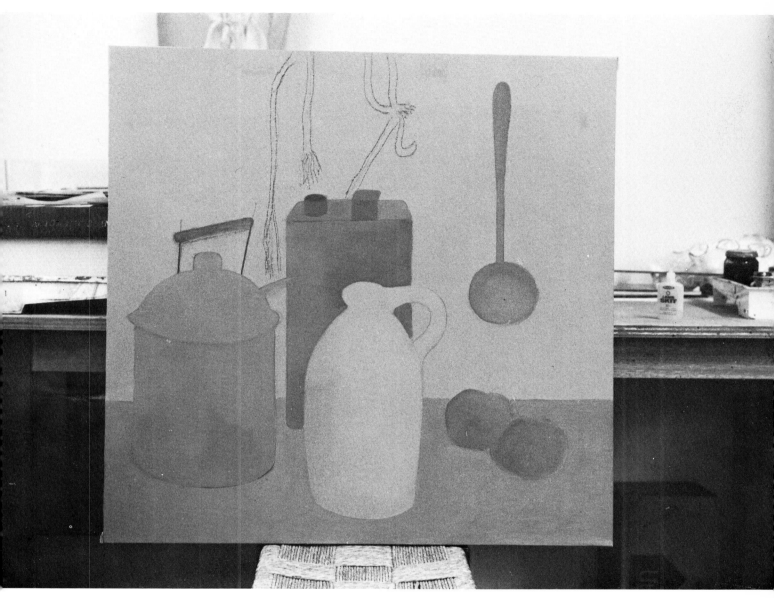

Finish of details, such as the twine and hook at the
top of the painting, is left until the end.

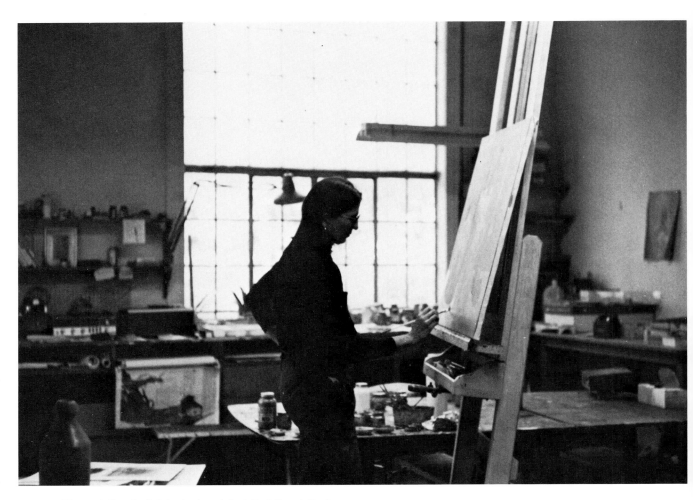

The painting is finished when I feel that the delicate balance of all its elements is as "right" as I can make it.

"Every part of the painting receives as many as five or six transparent coats applied in this way — thin veil over thin veil — so that one color shows through another to create depth and luminosity. Building slowly, coat by coat, I'm able to maintain careful control of the entire surface, to keep a balanced relationship between all the parts, between the objects in the foreground (positive shapes) and the background (negative) shapes.

"And when I feel that this delicate balance has been realized all that's left to do is finish the details such as the rope and pulley, the handles, perhaps a touch more color in the fruit."

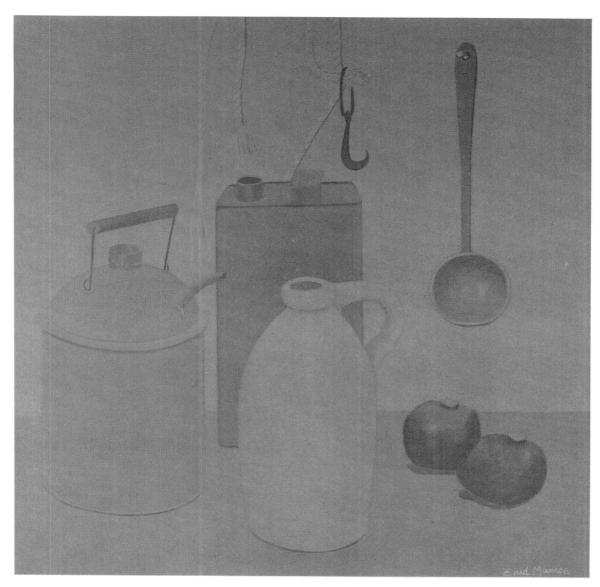

Still Life With Pomegranates.

5 WARD BRACKETT

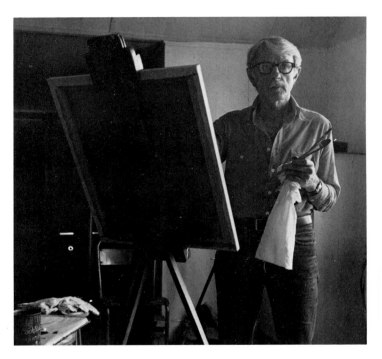

The artist at work

His finished still life

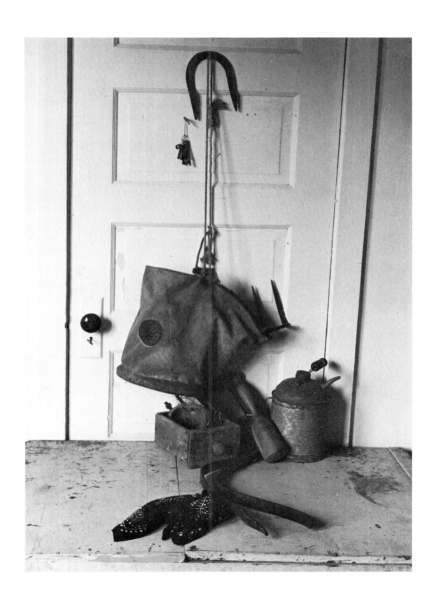

The set up. A bandana
handkerchief in the foreground
adds directional movement
and a spot of color.

85

Arranging the set up. The possibilities are endless.

The problem is to place the objects in a way that will be of the most help in composing the picture.

After attending the Layton School of Art in his home town of Milwaukee, Ward Brackett moved to Chicago and then New York City to establish himself as an advertising and editorial illustrator.

For many years thereafter his elegant illustrations were familiar to readers of some of the foremost "slick" magazines, including McCalls, Good Housekeeping, Cosmopolitan and Redbook.

While meeting deadlines and pleasing the art directors, editors and readers of these publications he maintained an active interest in all aspects of painting, particularly in working from nature. The result was a continual output of landscape, still life and portrait paintings.

In 1953, under the auspices of a U.S.O. (United Service Organization) — Society of Illustrators project he did portraits of Army and Marine servicemen in Japan and Korea. On a subsequent trip abroad, this time for the U.S. Air Force, he toured Spain making reportorial drawings and paintings.

He has always continued to search and grow as a painter, independent of his commercial work. To this end he went back to school in mid career, attending Reuben Tam's classes at the Brooklyn Museum.

Since then his paintings have been in gallery and museum exhibitions in New York,

Connecticut and Florida. He is represented by the Watson Galleries in Naples, Florida; Portraits, Inc., New York; the Brinsmaid Gallery, New Canaan, Conn., and the Portrait Gallery in Westport.

For Ward Brackett painting is an enjoyable interpretation and expression of what he enjoys seeing. His experience, philosophy and techniques are lucidly set forth in his book, *When You Paint.*

"I like a still-life to look as much as possible like an accidental arrangement of objects, like a happening rather than a deliberate set up of the kind we used to do in art school where we carefully placed a pewter tray and a wine bottle and some fruit or vegetables against a piece of colored drapery tacked to the wall. I'd rather have the subject that I'm going to paint look as though it had naturally evolved and I'd come along to catch it just at the right moment.

"But that's not always easy. It can take a lot of careful arranging to get a natural, careless look. Sometimes you just can't do it at all. I've often found that in setting up a still-life the more I work and fuss the more planned and deliberate it looks. Sometimes I can help solve that problem by turning my back and throwing an object in there without looking, especially if it's cloth.

86

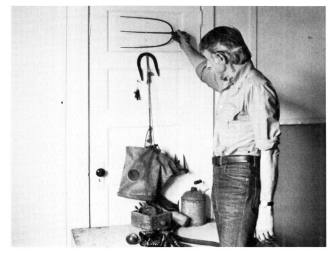

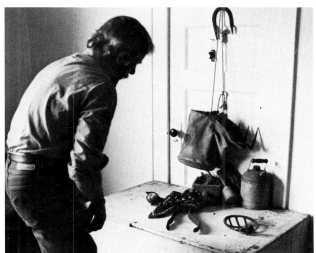

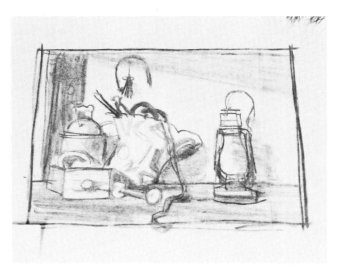

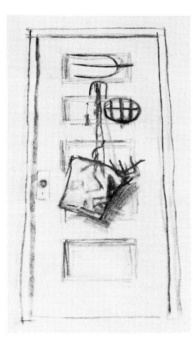

As I try each arrangement I make a quick charcoal sketch to aid me in visualizing how it might work as a picture.

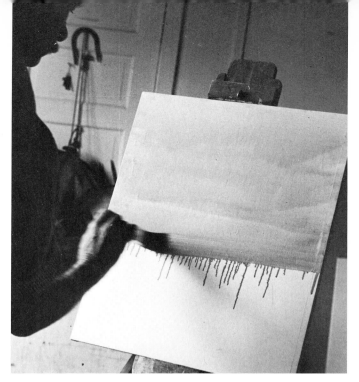

A thin wash of yellow ochre and cadmium yellow mixed with a generous portion of turpentine gives the canvas a golden tone that sets an appropriate mood for the mellow old objects that are its subject.

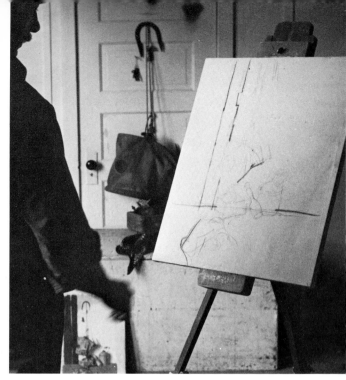

The toned canvas is allow to dry for twenty-four hours before it is ready to draw on.

"I find certain objects more exciting than others because I respond to their particular shapes or to the idea of what they represent. I'm usually better off limiting the number of objects I try to put into one painting. Also, it's a good idea to confine yourself to things that are compatible with each other, that all come from the kitchen or all from the tool shed, rather than to try to mix fruit or kitchen ware with outdoor tools and garden implements. If the objects don't belong together thematically they're going to have a jarring effect in the painting.

"For this still-life I have chosen from the prescribed objects those that for me have the most interesting shapes. I particularly like the shape of the horse's feed bag. One of my first decisions was that the best way to show the shapes of these things and at the same time to keep them in a logical and natural setting would be to put them against a plain white wall, suggestive of the white washed wall in an old barn.

"My first approach was a rather formal arrangement. Then I abandoned that and tried shoving things around so they looked as though they'd been there collecting dust for a long time. I may rearrange a good many times before I get something I like. As I try various arrangements I do a quick charcoal sketch of each to plan the composition.

"The light and how it falls on the set up is important. As I'm working on the arrangement I keep moving around it to explore all the possible viewing angles. The principal light is coming from a row of windows to my left as I face the still-life. The more I move to the right the more I see of the shadow side of things. The cast shadows can be just as interesting as the shapes of the objects themselves.

"When I'm satisfied with the set-up and have chosen the position in which I'm going to work I make a quick color sketch to get an idea of how my painting will ultimately

88

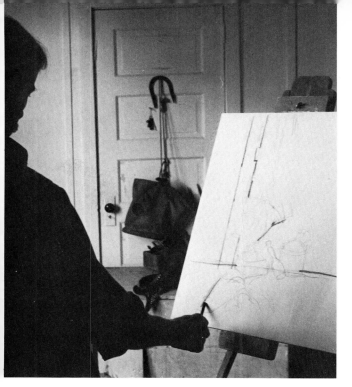

The drawing on the toned canvas is made with charcoal.

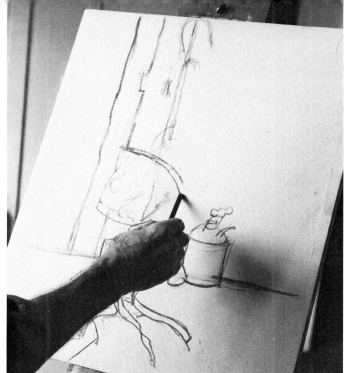

I like the shape of the horse's feed bag which occupies an important place at the center of the composition.

look. I do this on a small gessoed panel using acrylic paint because it dries fast.

"For the painting itself, however, I'm using oil on canvas. Oil is a more flexible medium and I feel that it's appropriate to the subject. This is a cluster of time-worn antiquities that call for a mellowness that you can get with oils, whereas acrylics give a harder, harsher effect.

"I'm working on a 20 by 24 inch Belgian linen canvas. The day before I'm going to begin painting I tone the canvas with a thin wash of color. In this case it's yellow ochre and cadmium yellow mixed with lots of turpentine. This gets rid of the glaring white of the ground and establishes an over-all golden tone that's appropriate to the yellowish brownish scheme of this set up.

"After the tone has dried — I like to give it 24 hours — I make a charcoal drawing that establishes the big shapes and their proportions and placement. Now I'm ready to begin painting.

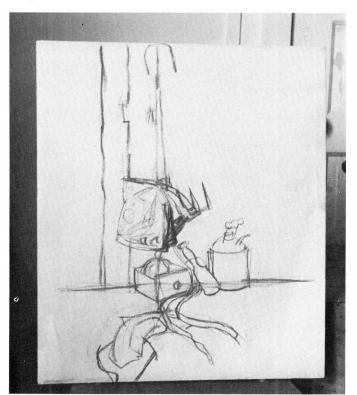

A free and loose preliminary sketch is sufficient to suggest shape, placement and movement. There's no need to carry it further than this.

89

The subject and the mood that these antique objects evoke call for a softness and mellowness that I can best obtain with oil paint.

I use a disposable paper palette which I tape to an enamel butcher's tray for firmness.

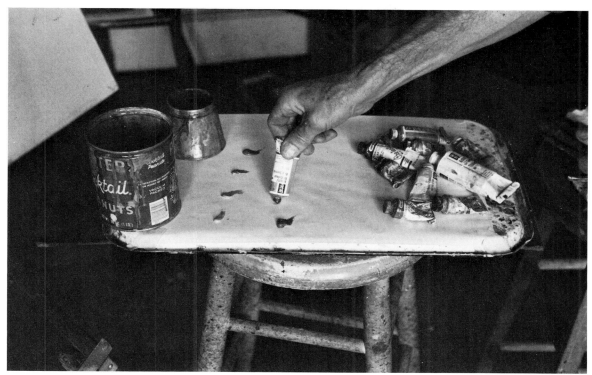

Because the color range of the subjects is restricted only a relatively limited number of colors is set out on the palette.

My inventory of brushes for oil painting includes flats and rounds, small and large, all the way from a number 2 to a 3 inch house painting brush.

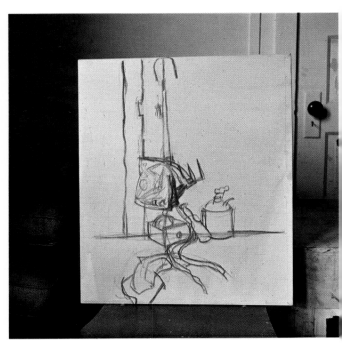

Warm colors: cadmium yellow medium, cadmium orange, cadmium red light. Cool colors: manganese blue, cobalt blue, ultramarine, viridian. Earth colors: yellow ochre, raw sienna, burnt sienna, burnt umber.

The yellowed tone of the canvas will influence and serve as a reference point for color applied over it.

"I set out my paint on a disposable paper palette which I tape down to an enamel butcher's tray. Here I'm using a limited palette because the subject itself is limited in color. My colors are cadmium yellow medium, cadmium orange, cadmium red light. Then the earth colors — yellow ochre, raw sienna, burnt sienna, burnt umber. For the cools I have manganese blue, viridian, cobalt blue (the purest blue there is), ultramarine. And, of course, white. I don't use black per se. Burnt sienna and ultramarine make an "almost black" that I prefer.

"I work from dark to light. By putting in the darks first I feel more confident that I'm sustaining the structure of the composition. Also I find that later on I usually don't need

so many middle and light tones. The darks will carry the picture pretty well by themselves.

"So, using a deep brown, I begin. At first this is really an extension and strengthening of the preliminary charcoal drawing. I'm emphasizing certain lines that need to be emphasized. I start looking for movement in the composition. There's a certain lack of flow and swing so I bring out the rhythm by strengthening some lines and losing others that aren't contributing to the rhythm. For example, I emphasize the way the line of the bandana handkerchief turns the eye and leads it back into the picture. A similar thing happens at the top where the horseshoe directs the attention back to the center

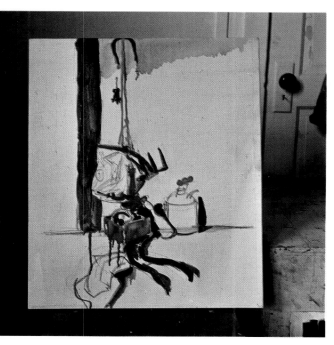

The darkest values and shadow areas are painted in first.

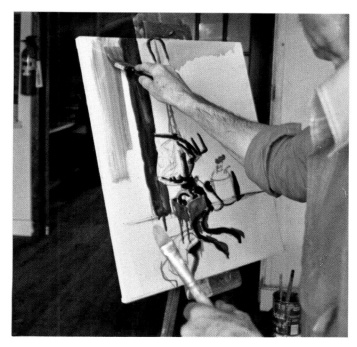

Test areas of blue grey and yellow ochre come next.

Right. The paint is kept very thin and fluid at this stage and applied with a broad housepainter's brush.

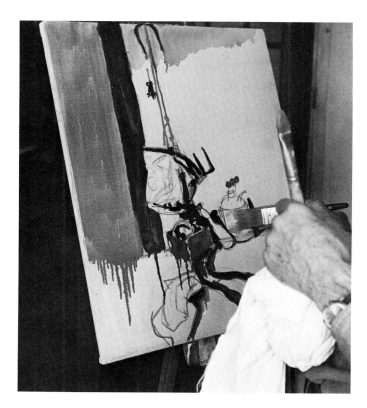

of the composition.

"All this builds up a kind of fluid action that holds the whole thing together. Then come the larger dark areas such as the accents of the feed bag, around the pestle, the bandana and the vertical wooden post which is the largest dark mass in the painting.

"It's an underpainting, really, in which I adjust and continue the drawing before I get into color. I go further with this lay-in stage than will show in the finished picture. Some of the dark lay-in will be overpainted as I get into the lighter tones.

This is the sort of thing I don't want to fuss over. You lose the natural flow if you don't swing it in quickly and freely. You keep

93

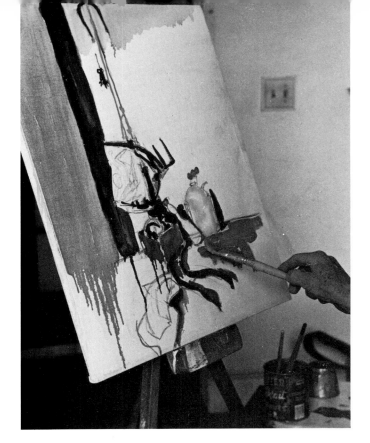

The painting process begins with a reaffirming and strengthening of the charcoal drawing.

appraising what you're doing as you go along, to be sure that you're getting the rhythm and action. If you're not getting it it's a good idea to make the necessary changes at this stage. Not that you can't make changes later but it's better to get it as right as possible before you've committed yourself too far.

"The next stage is moving in on the broader areas. Now, as I brush in the feed bag, the table top and the rest of the big shapes I'm

Key lines are emphasized, along with the linear flow of the composition.

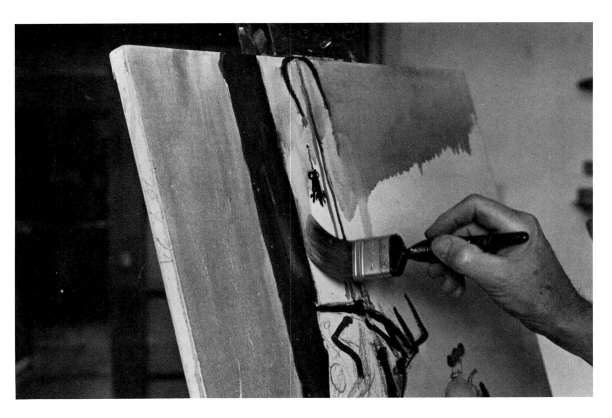

94

Here I've brushed in the large masses of foreground and background.

beginning to work with the lighter values, to develop the middle tones and accents. All during these early stages I use a good deal of turps. It's an old cardinal rule of painting — work from lean to fat, from thinned down pigment to the oilier, more opaque application of color. Not only is it chemically sound because it helps to prevent ultimate cracking of the surface but it gives the effect of looking into a painting, a feeling of dimension.

At this stage I still work freely and quickly to keep the natural flow moving. Details are left until later.

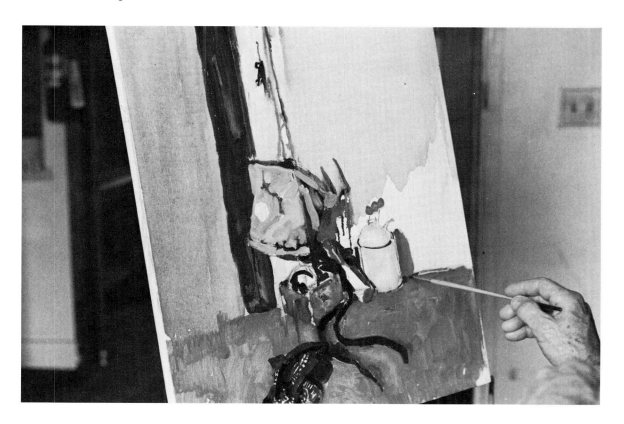

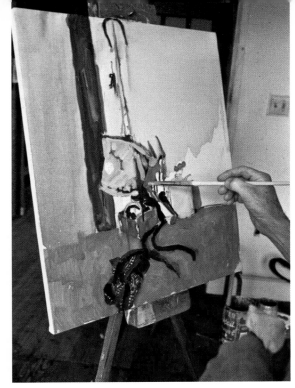

The various areas of the picture are out of balance until I can block them in with their approximate color and value. Then it is a much easier matter to make the necessary adjustments.

I don't do all the color mixing on the palette. Often I dip the brush directly in several colors and let them mingle with the brush stroke on the canvas.

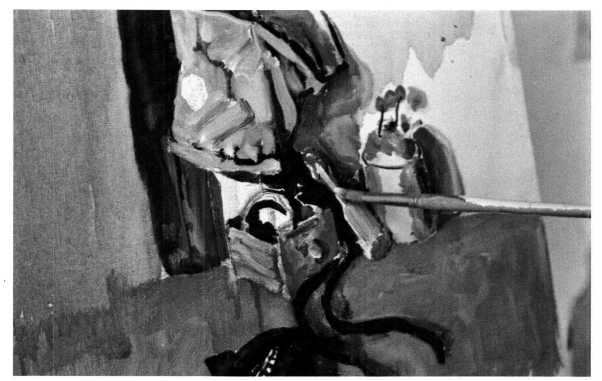

Even though I must shift to a smaller brush for smaller areas I still refrain from dealing with details.

"As I get into color I want yellows to predominate, even though in my little color sketch there's a lot of blue in the shadows. Many beginners have a tendency to make their shadows colorless. They just make them brown or dark gray or bluish. But there's a lot of color in shadows. They should be kept alive. So I work in some warm tints — a few touches of cadmium red, for instance, immediately lend a little life.

"I like to put the paint on without mixing colors on the palette. I dip the brush directly in a little green, a little red, a little burnt sienna, stroke it right onto the canvas and see what happens. But I don't brush it around after it's on because it's apt to turn muddy.

"When you're working into an area that requires a new color it's better to approximate that color and try a little on the canvas than to try for an exact mix on the palette. Step back and see if it's right. If it isn't, change it, but don't fuss and fuss trying to mix it exactly the right hue and value before you've seen what it looks like in place in the painting.

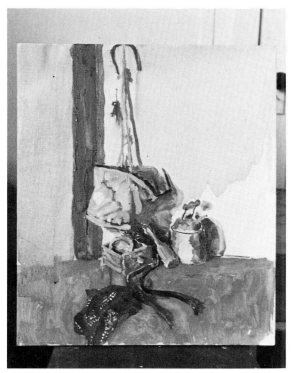

Now the surface has been virtually covered and I can begin to judge the overall balance of color and value.

97

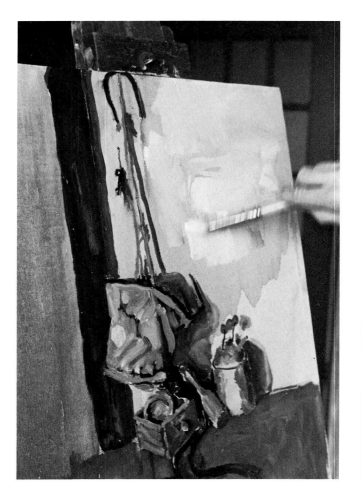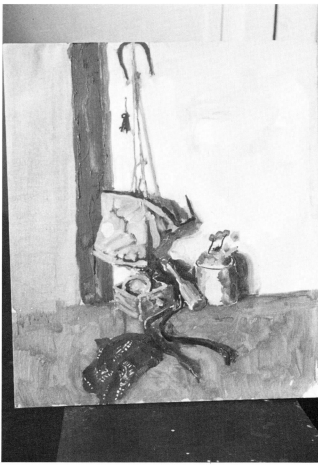

As I paint the background I keep in mind the foreground shapes, cutting into them where necessary, overpainting edges, making changes and corrections.

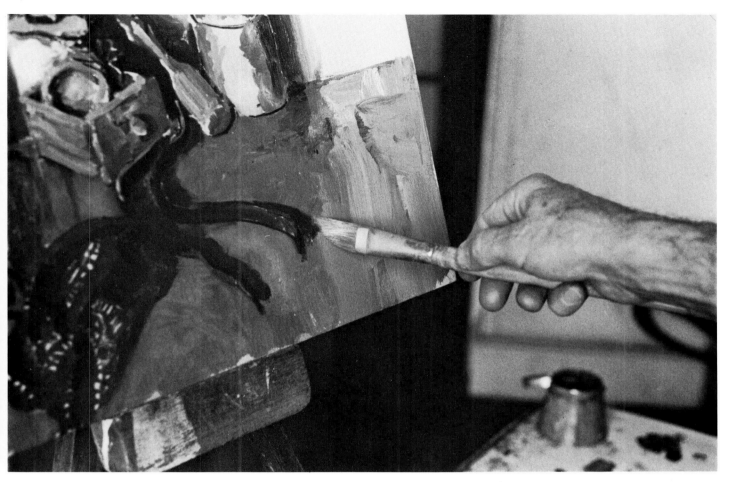

Here two things are happening: I'm brushing in the foreground base and at the same time molding and shaping the leather strap as I paint around it.

"The same principle applies to the shapes. I don't worry about getting them all exactly the way I want them at the first crack. I can always paint into them and reshape them as I brush in the negative shapes of the background. In other words I'll put down a shape with approximate accuracy and then later, as I paint around it, I can cut into it and shape it almost as though I were sculpting.

"I paint rapidly, just as though I were working out of doors. I don't want to stop and intellectualize. I want to paint what I see and get it down as fast as I can before I have time to think about it too much. It's an instinctual process . . .

"In my training as an illustrator I was taught to polish everything to perfect finish. But in this kind of painting you can forget about making everything perfect. Some of Matisse's paintings seem sloppy in places but the sum of their parts makes them great.

"A painting grows. Don't let yourself

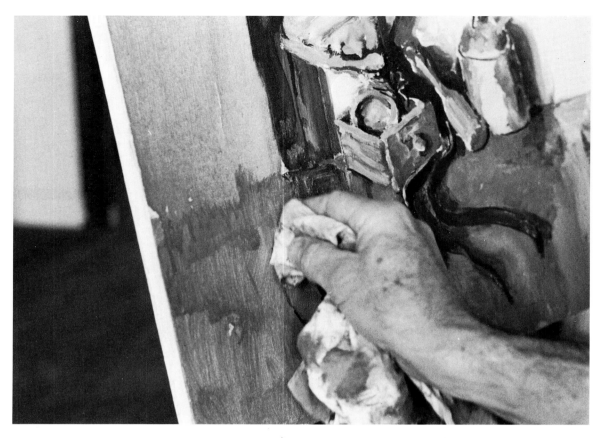

Things happen that aren't planned, oftentimes for the better. An important part of painting is deciding what to leave alone and what to change or eliminate.

become stuck in one spot. Keep working over the entire canvas. Keep building it up. I'm never quite sure how things are going to come out. It's always an adventure. If you're too sure of what you're going to get, you're apt to become stereotyped.

"A lot of things happen that you don't plan. You have to decide what to leave and what to change. The decision is often intuitive. I may be painting away and have the good fortune to get effects that I like. I can't explain why: I only know that I've done something that's right.

"There comes a point where you're tempted to get in too much detail. I want to be careful to leave it before I belabor it. As you work and concentrate on the problems involved the eye loses its fresh critical perception.

As the painting nears completion the rate of progress is likely to be slower. Now is the time to step back more often and think about where it's going.

Avoid getting trapped by details. It's important to know when an object or area has been carried far enough.

It is easy to overwork instead of stopping at the right time. So toward the end it's a good idea to step back more and more often to appraise what's been done. Less painting and more looking is the rule at this stage. Sometimes you think a painting is only half finished when it's actually a lot closer to being done, as you'll realize if you step back and look more often.

At this step I feel the need for a spot of red, which I achieve by introducing the apple. It must be placed in such a way that it fits the composition and does not look like an afterthought.

"In its final stage this painting seems to me to be crying for a little bit of red. So for color and shape I decide to put in an apple. An orange or a flower might work as well but an apple seems to go more comfortably with the other objects. It's homey and American and looks natural in a barn.

"I must be careful about its placement, however. I don't want it to declare itself as an afterthought. It must look as though it belongs, as though it happened at the same time as the original arrangement.

"The last thing is a final shaping of the objects and the shadow edges which I do by painting into the luminous white of the background wall, bringing it up to the darker areas and making it determine their finished contours.

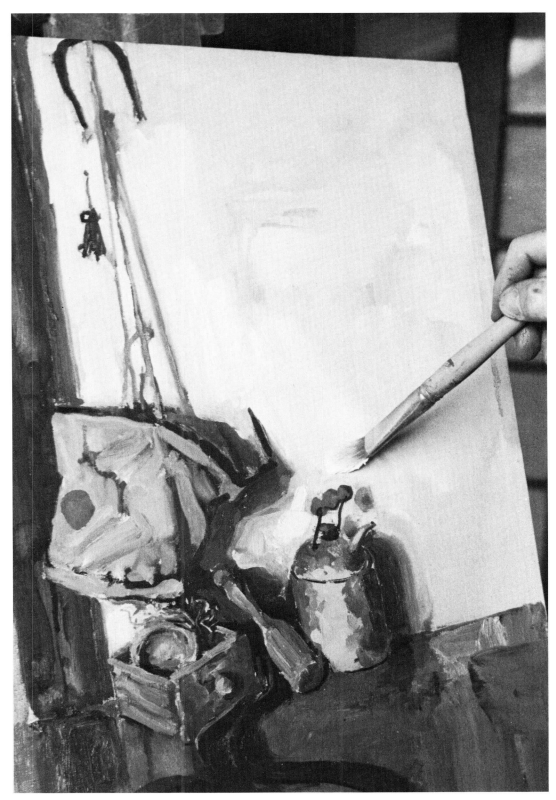

Final touches to the background include particular attention to shadow edges.

At the very last I decide that the composition can be strengthened by reducing the over-all size of the canvas.

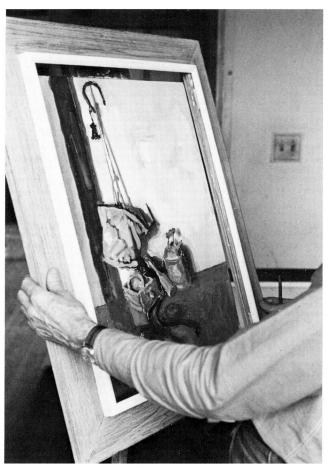

The completed canvas, restretched on a smaller stretcher, is now ready for the frame.

"As the painting was just about finished, I saw that I'd goofed in locating the position of the kerosene can and drawer. The line of the edge of the table was so low as to make the placement of these objects impossible unless they were imbedded in the wall. So — up goes the line of the table which will move them away from the wall.

"This is turning onto an exercise in second thoughts. I decide now that the still life can be made more interesting by closing in on it. This requires moving the horseshoe down and lowering the shadow along the top of the picture. The canvas was then remounted onto smaller stretcher strips and the picture was now ready to be framed."

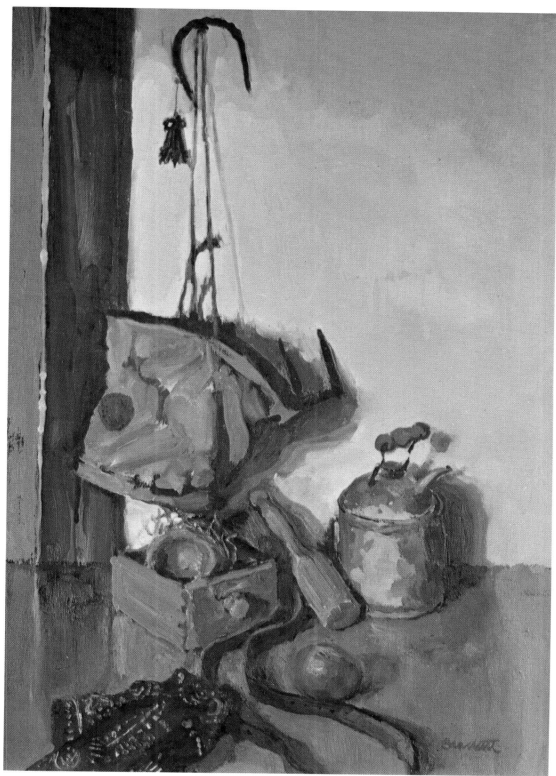

The Old Feed Bag

6 ALPHONSE RADOMSKI

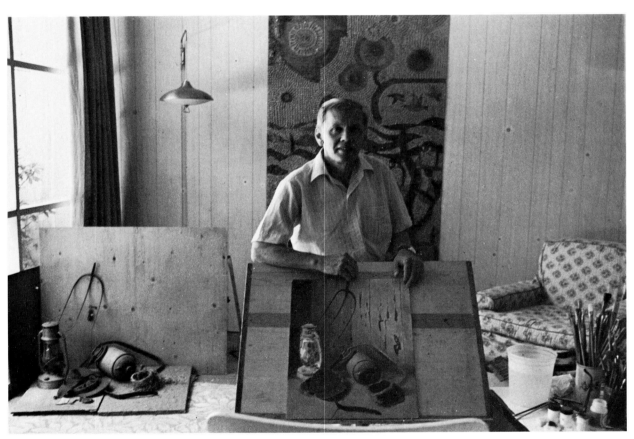

The artist in his studio, with his painting partially completed and the still life set up in the background.

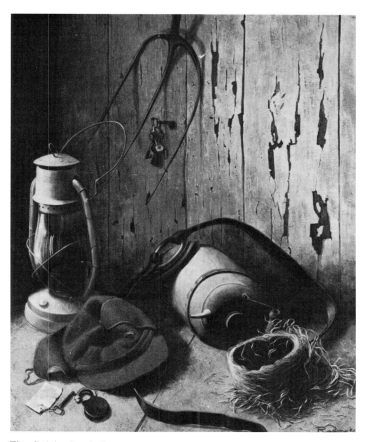

The finished painting.

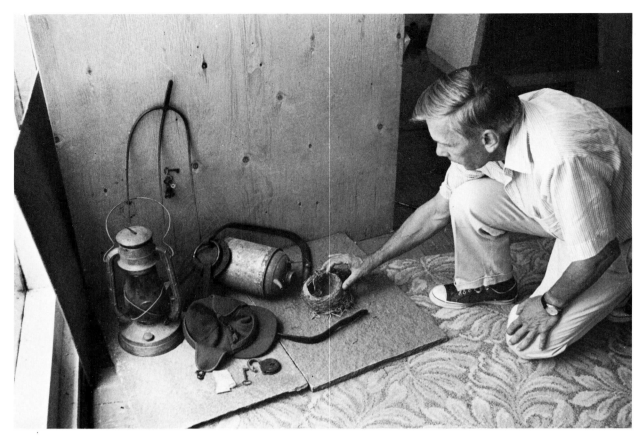

The elements were selected for their textural differences and variety of shape.

Al Radomski learned the egg tempera painting technique at the Yale University School of Fine Arts. Throughout his painting career egg tempera has remained his favorite medium.

"I always wanted to be an artist," he states. "I was sickly as a child. What do you do when you're a kid in bed? You draw. I can't remember ever not doing it."

After graduating from Yale he taught art and continued to develop as a painter of landscape and still life. A visit to the American southwest influenced his painting and thinking, resulting in the many fine western landscapes that have comprised a large part of his more recent output.

He is a winner of the Kosciusko Foundation award and a National Academy of Design prize for landscape. His paintings have been exhibited at the Metropolitan Museum of Art, the Yale Art Gallery, the Grand Central Galleries, the Audubon Society, the St. Louis City Museum and the Hartford Athenaeum.

After many preliminary sketches, I tried both a horizontal and a vertical version of the composition.

"Color, or more accurately the absence of any strong color, was my first impression when I saw the objects that were to be the subject of my still life. They were gray and brown. So in making a selection my chief consideration was variety and contrast of textures.

"Another consideration was that certain of the objects had personal meanings for me that attracted me to them. The lantern, for instance: I knew I was going to use it as soon as I saw it. It brings back memories of my boyhood and the old chicken coop, and going out to feed the chickens. The kerosene can, too, I associate with those memories. The smell of the kerosene was part of the lantern. And the bird's nest — I guess almost all children are fascinated by bird's nests.

"All these things came from a New England barn and they made me think of place — of what they were part of and their relationship to each other. Some of them were interesting for their shapes. I particularly like the shape of the rusty pitch fork.

"I arranged them on the floor of my studio, on a large flat stone that suggests a barn floor and gives me still another contrast in texture. Because the colors are so limited in range I incorporated the hunter's red hat into the composition to pep it up a bit.

"To begin, I made two preliminary charcoal drawings, one a horizontal format, the other vertical. My first reaction was that I preferred the horizontal and that would be the way to do it. But when I tried a full scale drawing from it the composition didn't quite work. The shapes got too cramped and it looked as though I'd have to cut off that pitch fork that I like so much. Therefore I decided on the vertical.

109

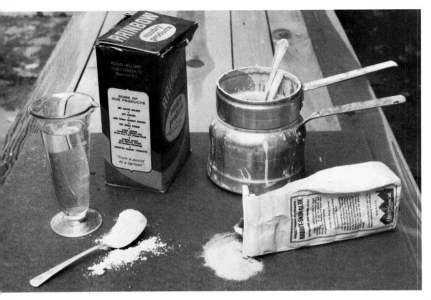

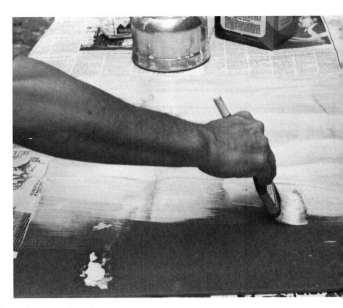

After selecting the vertical shape, I cut an untempered Masonite panel to the same size. This was then coated with my own formulated gesso ground.

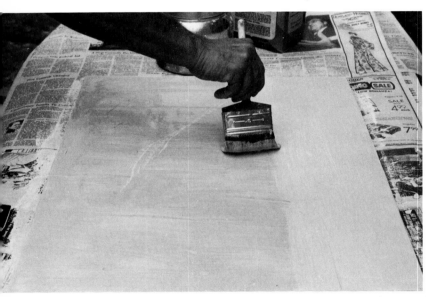

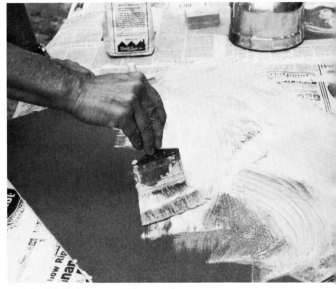

The front of the panel was given five coats of gesso. After each dried the successive coats were brushed on at right angles to each other. The back was also given one coat to prevent warping.

Once the shape and size of the painting have been determined I'm ready to prepare the panel. My preferred painting medium is egg tempera, for which I find untempered Masonite the most convenient and practical thing to work on. When I have cut the Masonite to the shape I want I sand the edges to get rid of any rough places left by the saw and it's ready for the gesso ground.

I prepare my own gesso by mixing one ounce of rabbit skin glue to ten ounces of water. The water is heated in a double boiler and the glue is stirred into it until it's completely dissolved. I then add dry, powdered whiting, a little at a time, stirring constantly so it won't get lumpy. I keep slowly adding

The back side of the drawing is blackened all over with a soft 4 or 5B pencil.

The drawing is then taped to the panel and traced with a harder pencil to transfer it to the panel.

With the drawing on the panel complete, the next step is to prepare the egg tempera medium which consists of egg yolk and water in equal parts.

First, the egg is carefully broken and the egg white drained off.

The yolk is placed on an absorbent towel to remove any remaining albumen.

The egg yolk is then dropped into a glass jar and vigorously stirred with an equivalent amount of water.

The prepared medium is stored in a small jar which can be covered when not in use.

My underpainting will be done with a mixture of the medium and designer's colors — in this case, burnt umber.

The medium, or binder for egg tempera is egg yolk and water in equal parts, shaken well in a tightly capped jar to form a smooth emulsion. My pigments are designer's colors, which are similar to water colors. I use sable brushes, dipping them into the medium and then mixing with the color to whatever consistency I need for the particular effect I'm striving to achieve.

I do the underpainting with burnt umber and a half inch sable brush, loosely painting in all the shadow areas. In places I reinforce the line drawing with a fine brush.

As the paint comes from the tube, it is too dry and opaque, so the brush is continually dipped into medium to provide the necessary transparency and fluidity.

The lay-in is primarily to establish the tonal relationships and is painted in fairly rapidly.

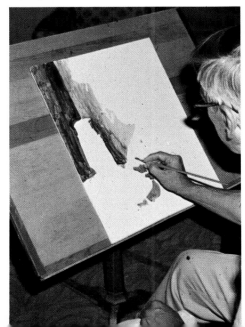

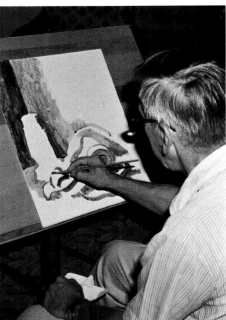

115

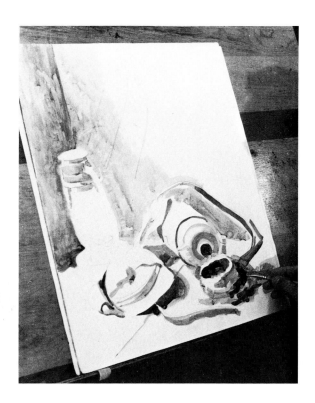 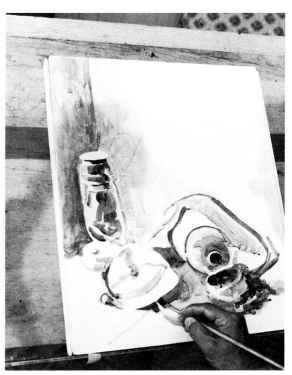

I first concentrate on the darkest shadow areas, then add the intermediate values of the background.

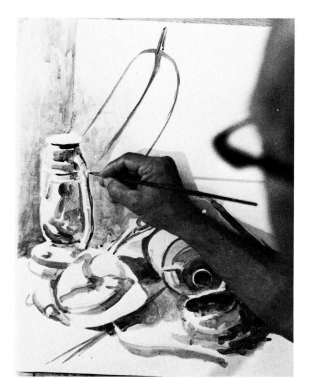 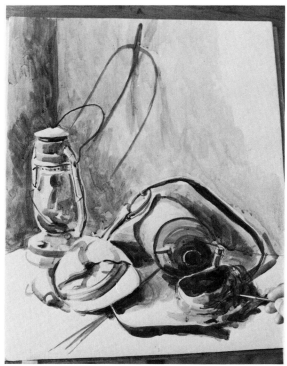

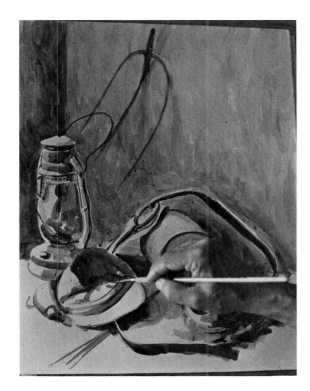 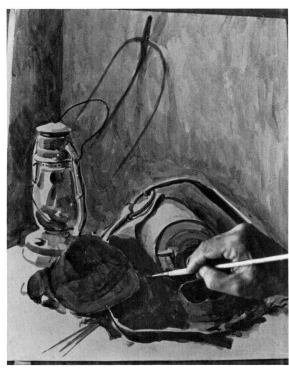

Next, I approximate the local color values of the objects themselves. All are still painted in a monotone of burnt umber.

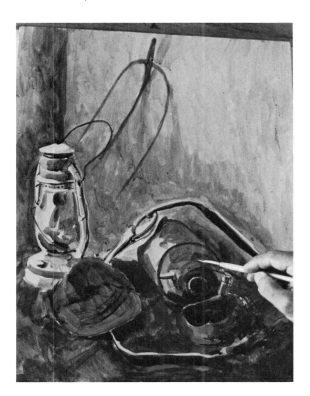 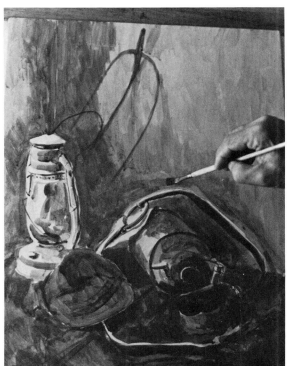

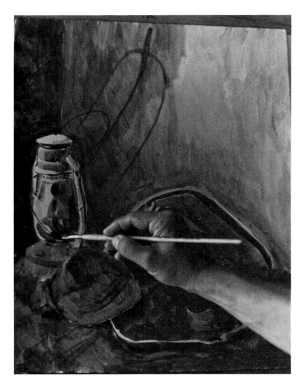 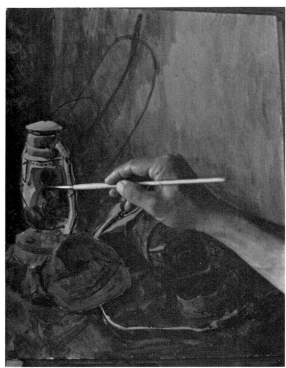

Along with the tonal development, refinements are also made in the objects' shapes.

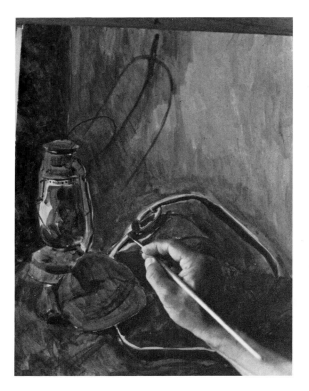 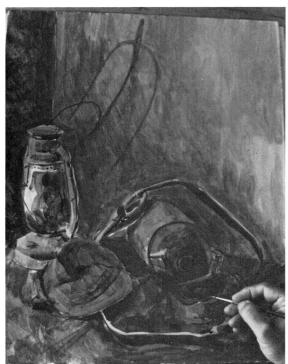

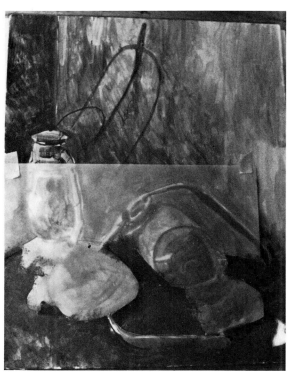

By cutting a tracing paper mask, I can isolate the flagstone area and introduce some textural effects with a small sponge. These can be controlled by subsequently glazing a tone over them. A straightedge helps to define a crack in the stone.

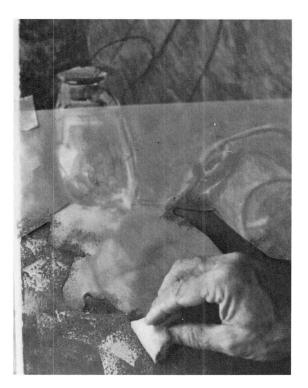

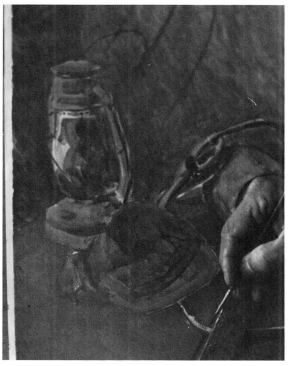

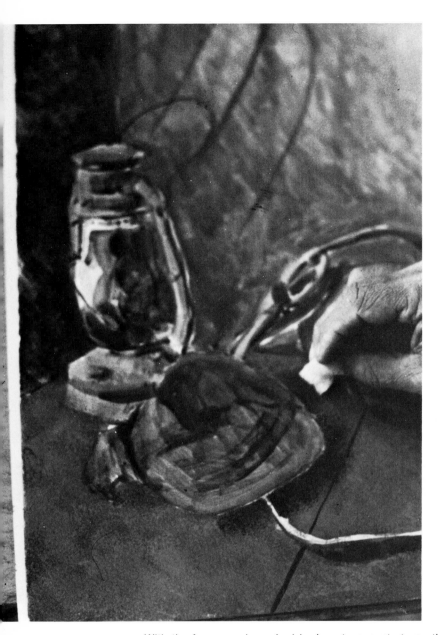

With the foreground roughed in, I next concentrate on the background wall. A series of photos of an old paint-peeled wall I had made some time before now served as an excellent model. I painted right over such details as the pitchfork and lantern handle knowing that I could retrace them from my original drawing when needed.

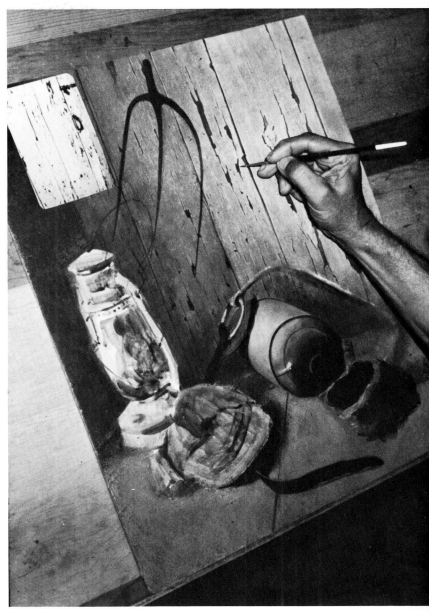

The pitchfork and lamp handle are now retraced and painted in silhouette, giving me reference points for further refinement of the background textures.

"When the darks are laid in I begin painting each object. The red hat is the only note of bright color in the picture so I rough that in at the beginning to give me a color notation as a point of reference. But ordinarily I make a practice of beginning with the background and working forward. In other words I first paint what is farthest from the viewer in the still life set up, then the next nearest object, and finally the foreground.

"In this case the background is an old whitewashed wall of worm-eaten boards. It's based on a wall I saw and liked the looks of and photographed. In using it as the background for this still life I worked from the photographs.

121

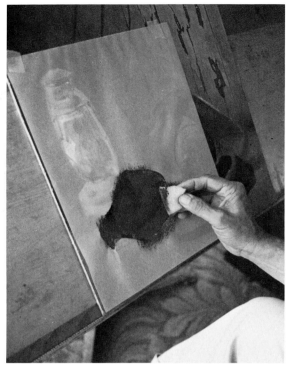

Now it is time to work on the hunting cap. Again an isolating mask of tracing paper was made and taped in position. The red paint is patted on with a small sponge.

"I find sponges very useful and have resorted to them a good deal in this painting. With a sponge I can tamp an area of transparent color on over the underpainting, as I have for example with the red hat. The darks come through the flat glaze of color with the result that I get not only the shape and form of the object but an appropriate textural effect. A sponge was helpful also in interpreting the texture of the stone on which the objects are placed. I work back over these glazes with opaque, slowly building up the lights. I used the same treatment for the bird's nest, sponging a transparent glaze over the umber underpainting and then working over that with opaque lights.

"In this way I work back and forth, glazing, building up the lights, perhaps glazing again, going back in with the opaque wherever it's necessary.

The glass and metallic parts of the kerosene lantern are built up at the same time.

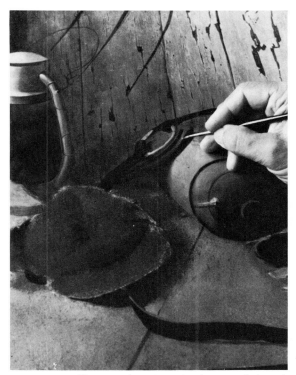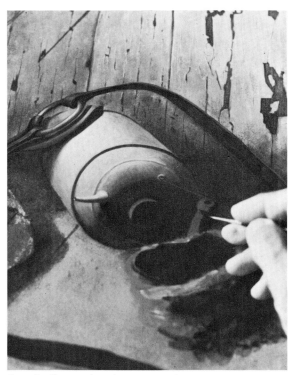

Since each part must relate to all the others, I work all over the picture, carrying each part another step forward.

Now I can more fully define the lantern, adding finishing details since the basic structure is established.

I work with a very small brush on details such as the lantern handle which includes both highlight and shadow areas.

The hunting cap is next, not painted broadly but with countless tiny strokes to simulate the texture of woven cloth.

124

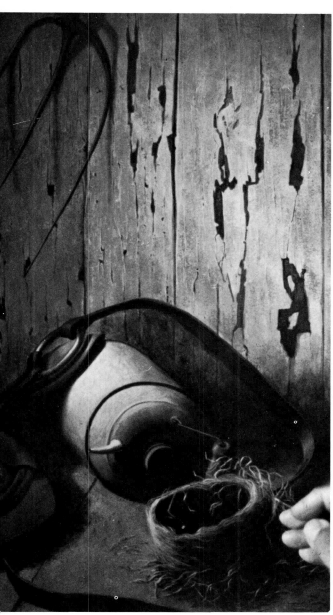

By working from the background to the fore-
ground, I can overlap areas already painted.
The grass strands of the bird's nest illustrate
this process.

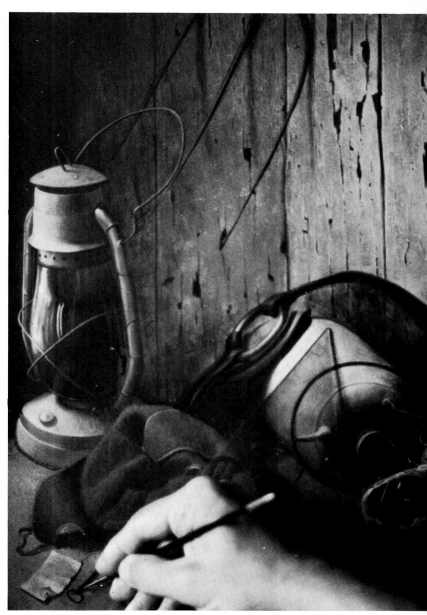

A plastic triangle acts as a protective support
for my hand in painting fine details such as the
lock and key in the foreground.

 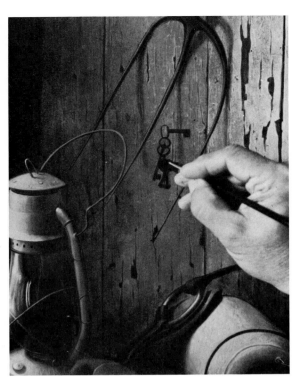

The final objects are a ring of keys hung on a nail in the wall. These are plotted out carefully on my master drawing then traced into position and painted.

"It's a slow process. I'm interested in realism and I achieve it to a large extent with textures. I want one thing to look soft and another to look hard. And of course it's important for the values to be right, too, with the contrasts of dark, light and halftone that distinguish one shape from another.

"Only when I'm satisfied that I've gone as far as I can in creating a realistic image do I consider the painting finished. There's always more you can do. In a way a picture is never done. But there's a point at which you feel that you've done your best, that your statement is complete. If, after looking at it for a few days and it still holds up, you leave it at that, and the picture is ready for the signature."

Highlights provide the finishing touches.

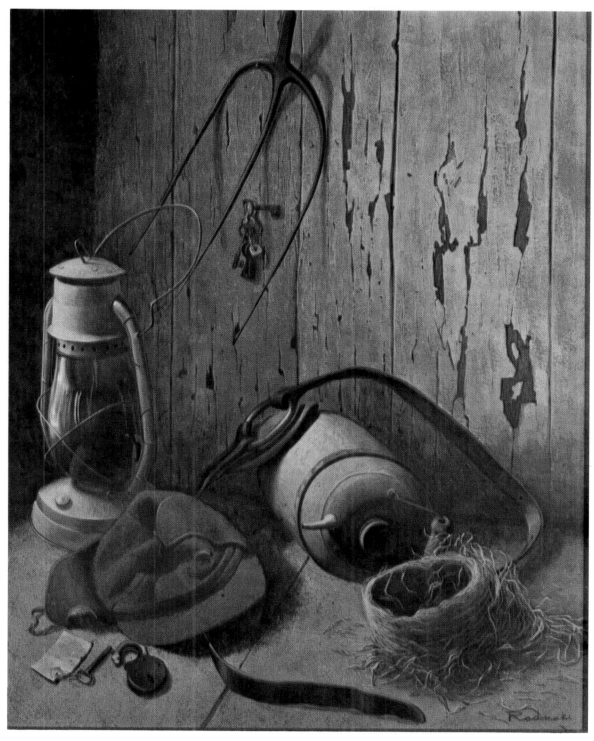

The Lost Cap

127

POSTSCRIPT

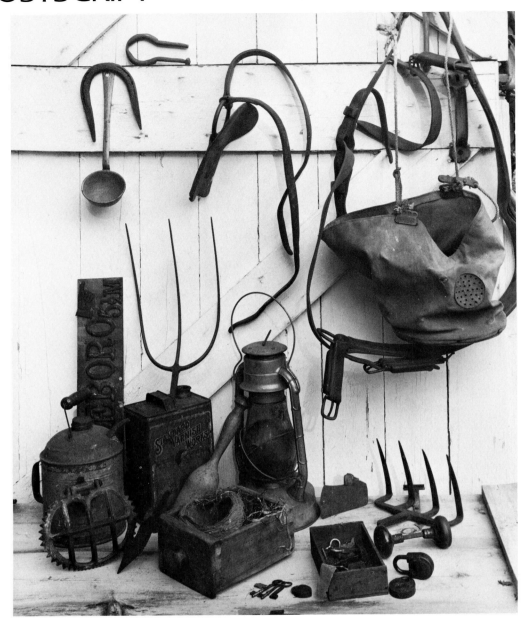

An important contributor to this book has been photographer Bill Noyes. He, with his daughter Debbie who is also a talented photographer, did the picture story for a previous book in this same series, 6 ARTISTS PAINT A LANDSCAPE. It has been his task to anticipate and record the significant stages in the painting process of the artists, working intimately yet unobtrusively behind each artist's shoulder.

We asked Bill to provide us with a "catalog" shot of the collection of props which had been gathered from an old barn so we could illustrate what the artists had been confronted with. Instead, he took it on as a challenge to do his own version of the painters' problem. The resulting photo was so successful that we have reproduced it here as an outstanding example of the art of photography and of Bill Noyes.